RICHARD DEMARCO was born in 1 [...] Italian parents whose families ha[...] [...] Britain via Ireland and France in the 19th century as a direct result of Garibaldi's 'Risorgimento'.

Whilst a schoolboy at Edinburgh's Holy Cross Academy, he was introduced to the Edinburgh Festival over a three-year period, 1947, 1948 and 1949. Thereafter, whilst studying Fine Art and Design at Edinburgh College of Art, he continued to be given the experience of the international art world through the Edinburgh Festival until 1953.

Since then, he has benefited from the experience of every Edinburgh Festival.

He co-founded the Traverse Theatre in 1963 as an extension of his classroom as Art Master at Edinburgh's Duns Scotus Academy.

He directed the Traverse Theatre Art Gallery which inspired him to direct the Demarco Gallery which opened in 1966 as a version of the Traverse Theatre and Gallery. The Demarco Gallery was transformed into a Scottish version of Black Mountain College. Thus, as a university of all the arts in collaboration with Edinburgh University's Schools of Scottish and Extra-Mural Studies, it initiated academic programmes in the form of expeditions from the Mediterranean and Eastern Europe towards the Edinburgh Festival.

In 1992, the Demarco Gallery was renamed the Demarco European Art Foundation. From 1993 until the Millennium year 2000, he was awarded a Stanley Picker Fellowship and established the Chair of European Cultural Studies at Kingston University.

For his work in helping to internationalise the cultural life of Scotland, he was appointed Commander

of the British Empire (CBE) and received similar awards from the governments of Italy, France, Germany, Poland and Romania, and the 2013 Medal of the European Parliament.

He has been awarded honorary doctorates from universities in Scotland, England, Poland and the United States of America.

A
Unique Partnership

RICHARD DEMARCO
JOSEPH BEUYS

Text and images by
RICHARD DEMARCO

Luath Press Limited
EDINBURGH
www.luath.co.uk

First published 2016

ISBN: 978-1-910745-60-1 Hardback
ISBN: 978-1-910745-59-5 Paperback

The paper used in this book is recyclable.
It is made from low chlorine pulps produced
in a low energy, low emissions manner
from renewable forests.

Printed and bound by
Charlesworth Press, Wakefield

Typeset in 11 point Sabon and Gill Sans
by 3btype.com

Contents

Acknowledgements

With thanks to Douglas Hall, Robert McDowell for their introductions, originally published in *Cencrastus* as was an earlier version of the Timeline. Thanks also to Raymond Ross, editor and publisher of *Cencrastus* and Steve Robb, guest editor of the Spring 2005 issue from which our material was drawn. Further thanks are due to Martin Kemp for his introduction, and Nicholas Serota for a piece originally published in *The Demarco Collection and Archive*. Thank you to *Performance* magazine, as well as everyone involved in *Bits & Pieces* (in particular Red Lion House and Arnolfini, Bristol), where several of these essays were first published. Thank you to the late Ryszard Stanisławski and Muzeum Sztuki and to Maria Anna Potocka at MOCAK. Finally, thanks to everyone who had a hand in putting together this book, in particular Terry Ann Newman, Chris Pearson at Giclee UK, Fernanda Zei, Lotte Mitchell Reford and everyone at Luath Press.

The Legend of Beuys

Those of us who met Beuys face to face must have learned more than we knew before about how legends are born. When I first met him in 1970 I was already acutely aware of the mythic character of contemporary art, with its claim to sanctify all that it chose to touch. Beuys had already designed the vestments for his particular priesthood, and they were hardly to change until his death. All this, like the constant presence of acolytes, made me resistant. But when a few years later he climbed with a single friend the stairs to the small flat in Rose Street where I was then living, and doffed his fedora for the evening, I recognised the magnetism of a founder, and felt the honour-conferring power of his attention and his deep knowledge of human affairs. He was a polymath in the German tradition, for whom European history and culture was a book to be opened and read at will, much of which he had remembered. With his millenarianism went a saving ribaldry and cynicism.

In 1980, I witnessed the sanctification of the old doors from Forrest Hill. With difficulty they were set up crookedly in the old Scottish National Gallery of Modern Art in Inverleith House, their size, crumbling paint and peeling posters affronting the niceties of the surroundings. Not knowing what he would do with them, I waited with great curiosity to see what laying on of hands he would perform. A single red bulb was placed in the gap between door and floor. What did it mean? A reminder of the sexual mores of old Edinburgh? Light creeping under the frightful constrictions of poverty and hopelessness that those old doors signified?

But it was enough. The Beuysian transformation already half effected by the change of context from poorhouse to gallery was completed. Beuys called the work *A new beginning is in the offing* (note his command of the English idiom), so perhaps he favoured the latter interpretation.

When we sought to think of a living artist who might both embody the ideas of the Enlightenment and understand its Scottish aspect, sufficiently to make a work at the new Gallery of Modern Art in its honour in 1986, it could only be Joseph Beuys. We felt he probably knew the passage from David Hume we offered him, like a baited hook. He would have liked to take the bait, but he was then too ill. He replied with characteristic courtesy, but as if from far away.

Some weeks later he was dead.

Douglas Hall
Formerly Keeper of the Scottish National Gallery
of Modern Art
for *Cencrastus*, Spring 2005

The Road to Muddle Segue

On a late August day in 1970 I drove from my home in Blanefield to Edinburgh to begin my annual round of the exhibitions. My expectations were not especially high. The visual arts were very much the poor cousin of the mighty official festival and its tumultuous fringe. There had been some worthwhile shows, and a few tremors of guerrilla curation by Ricky Demarco in his architecturally decorous New Town gallery. Early reviews had suggested that something notable was happening at the College of Art – apparently a group of more than 30 artists from Düsseldorf, a city about which I knew almost nothing. Some of the names rang bells, not least Günther Uecker and Heinz Mack, who had already featured in Ricky's gallery. But I was quite unprepared for what I encountered.

The sprawling, slightly tatty and intermittently grandiloquent School of Art had been infected by a creative disease that was transforming what we might think art was about. The palindromic *Strategy: Get Arts* startled with risky muddle in every available space. Shattered chairs littered the ample staircase, the walls of which were painted with aggressive squares of blue, yellow, white and red. Most engaging, at the highest level of suggestive complexity, was Joseph Beuys's battered vw van (best known in the UK as the dinky campervan for those who needed cheap getaways), from which spilled a ragged parade of 24 sledges, each bearing therapeutic fat and felt, together with a torch for dispelling mental darkness. Entitled *Pack*, it evoked for me the absent presence of the husky teams that bought some measure of human survivability to snowy wastes. It evoked much

else besides. Nearby in the Life Room, where generations of students had been disciplined to turn bodies into lines, was the expansive chaos of *Arena*, scattered visual documents of Beuys' events, those nuclear explosions of transgressive anti-capitalism. I confess that I missed the third part of his trilogy, the *Celtic (Kinloch Rannoch) The Scottish Symphony*. I am still kicking myself, but even so Mendelssohn will never sound the same.

The Düsseldorf crew was individually and collectively compelling. But for me it was Beuys who was definitively the Pied Piper of the whole, seductively drawing his entranced pack of followers on an inestimable march towards – something indefinable.

Few arts events are truly transformative. This was and is.

Thank you Ricky.

Martin Kemp
Emeritus Professor, Oxford University, 2016

Beuys, Demarco and Scotland

Scotland became for Beuys an incredibly powerful setting, a laboratory full of rich material immediately to hand for performances, drawings, talks, meetings and 'art-works' of many kinds. Demarco and Beuys worked with many of the same questions to which they were constantly drawn, such as the values of a spiritual and even mythic or generative power of special places and the people who are nurtured by them.

To both Demarco and Beuys, recognising and honouring the quality of places and the individuality of people and their ideas is a powerful antidote to the impoverishment of creative individuality and spiritual values in what is for many an increasingly profane and over-consumerist world. In their work, both railed against material and spiritual pollution. The ecology of such concerns prevalent in the '60s and '70s have again found a new generation for whom only an ecological understanding makes sense whether in art or science or political economy.

The history of the Demarco Gallery (now the Demarco European Art Foundation) has, since the 1960s, been one of issuing challenges to artists to come to Edinburgh and be open to all that is there and have their lives changed forever. This was a project of the most romantic yet most real kind. Demarco's specific challenge to Beuys was the same as that which Beuys issued to others; if you choose to live and work somewhere, not just as an 'artist', do not try to neutralise the context of your work in an 'art gallery' or an institution (not even a prison as in the dialogue with Jimmy Boyle), or in a narrowly defined field of work or study, but reach out

to embrace all that is available to give your own creativity its fullest personal and social power.

Beuys' holistic approach extended deep into his own personal experience and out beyond all the conventional barriers that have been erected to keep art safe and secure within a museum culture. He acknowledged many times the importance of his connections with Scotland. His many visits and projects, and the many other representations and promotions of Beuys by Demarco in hundreds of talks, the collections in the Demarco Archive, to which hundreds of people have contributed their work, ideas and recollections, constitute a major work over many years, extending after Beuys' untimely death in 1986.

Robert McDowell
Economist and artist
for *Cencrastus*, Spring 2005

On Richard Demarco

Richard Demarco is without doubt a remarkable man, an Italian Scot, a founder of the Traverse Theatre, a man who is an artist, a writer, a philosopher. He is a man who brought contemporary visual arts to the Edinburgh Festival. He has been involved in more than 50 Edinburgh Festivals, and he brought great artists like Joseph Beuys and Kantor to thousands of people. He has also brought the visual arts from other parts of the world, from Eastern Europe, long before other people were interested. And he's inspired us all, he's inspired us to take extraordinary journeys in the mind, journeys across Europe, journeys that he calls the road to Meikle Seggie.

Sir Nicholas Serota
Director, Tate, 2007

With regard to the exhibition entitled
Richard Demarco and Joseph Beuys:
A Unique Partnership

It should be noted that I regarded it my responsibility to introduce Joseph Beuys not only to certain aspects of Scotland's history and geography, geology and mythology, but also to the world of the Enlightenment in Scotland, with a particular focus of Scotland's Celtic culture related to that of Ireland.

I therefore made a special effort to introduce him to Edinburgh University's School of Scottish Culture and Extra-Mural Studies, particularly through their collaborations with the Demarco Gallery's experimental summer school, entitled 'Edinburgh Arts' which I established as a Scottish version of Germany's Bauhaus and America's Black Mountain College. This naturally led me to introducing Beuys to the reality of Shakespeare's 'blasted heath' – where Macbeth encountered his three witches – in the form of the Moor of Rannoch and thus to 'the land of Shakespeare', as he described it on our first meeting in his studio in Düsseldorf.

This year marks the 30th anniversary of the death of Joseph Beuys. It coincides with the 400th anniversary of William Shakespeare's death. It would therefore seem entirely appropriate that the exhibition I must prepare for the Scottish National Gallery of Modern Art should include a Shakespearean dimension.

The art of Joseph Beuys expressed his love of nature; the kingdoms of plants and animals far from the urban, man-made world. That is why I led him to the steep slopes of Arthur's Seat within a few hours of his arrival in Edinburgh, and then onto that road I now know as

'The Road to Meikle Seggie'. This is the road to Scotland's farmlands and woodlands and westwards, inspired by the famous folk song 'The Road to the Isles'. It is the road to the Hebridean, Celtic World of enduring legends, embodied in the world of Fingal and his son Ossian.

This is the world of cattle drovers and shepherds following in the footsteps of Celtic saints, pilgrims and scholars. It is unmistakably the world of Shakespeare's Forest of Arden in *As You Like It*, where Duke Senior accepts the natural world in direct contrast to that of the royal court from which he is banished when, in Shakespeare's words, he declares:

> And this our life exempt from public haunt
> finds tongues in trees, books in the running brooks,
> sermons in stones and good in everything

I was always aware that Joseph Beuys was the co-founder of the Green Party in Germany. His last great art work linked the world of the artist with that of environmentalists concerned with the problem of global warming. He regarded this art work as a new way, a new point of departure from the confines of the 20th century art world.

He entitled the work simply the *7,000 Oaks*. It involved him, in the last years of his life, raising the funds to plant 7,000 oak trees together with 7,000 basaltic stones, in the middle of the city of Kassel for the seventh *Documenta* exhibition in 1982. He was undoubtedly inspired by his experiences of Celtic Druidic culture and by the fact that Scotland's mountains were amongst the oldest on our planet.

Much of the art of Joseph Beuys took into account the nature of time passing.

In *As You Like It* Shakespeare expressed his thoughts on mankind's allotted timespan through the speech made by Jaques in a deep melancholic mood:

All the world's a stage,
And all the men and women merely players;
They have their exits and their entrances;
And one man in his time plays many parts,
His acts being seven ages. At first the infant,

Mewling and puking in his nurse's arms;
And then the whining school-boy, with his satchel
And shining morning face, creeping like snail
Unwillingly to school. And then the lover,
Sighing like a furnace, with a woeful ballad
Made to his mistress' eyebrow. Then a soldier,

Full of strange oaths, and bearded like the pard,
Jealous in honour, sudden and quick in quarrel,
Seeking to bubble reputation...

Mankind's lifespan of 70 years was taken most seriously when he equated it with the lifespan of the oak tree, as the noble 'king of the forest'.

If each oak tree is planted along with a basaltic stone formed from the volcanic origins of planet Earth then the *7,000 Oaks* sculpture is about the unfathomable past of the world currently inhabited by the human race. It is also a hopeful, positive statement regarding its possible long-term future.

In my interview with Joseph Beuys at the Brooks's Club in London we discussed how planting a symbolic oak tree or even seven trees or even 70 or 700 would be an inadequate statement because even 700 oaks

would not form a sizeable forest capable of visibly improving the quality of its environment. In the interview Beuys reveals his profound respect for the Celtic Druidic significance of the oak trees planted in a configuration of seven as in the Druidic site in England in the town of Sevenoaks. The Fibonacci Sequence provides conclusive proof that plants and trees grow in seven stages and that if you divide seven into three and four parts, you are considering the power of the Golden Mean, which sits at the heart of all manmade art works including the Temple of Athena Nike in Athens. Thus the goddess of beauty is forever identified with the number seven.

Sadly, the lifespan of Joseph Beuys was cut short and he did not reach his 70th year. He was 64 in 1986, the year of his death. Two weeks before, he telephoned me to say he would willingly explore the road from Edinburgh leading to the Argyllshire Valley of Kilmartin and plan the installation of a Scottish version of the 7,000 Oaks, by then well-established in Kassel.

Joseph Beuys took Scotland very seriously. He understood that the Celtic culture of Scotland is wedded to that of Ireland. He intended to experience Fingal's Cave, on what would have been his ninth visit to Scotland, in 1986.

Beuys had already taken the trouble to experience the Giant's Causeway on the Antrim Coast of Northern Ireland. He could clearly see the coast of Scotland from there defining the ancient kingdom of the Lords of the Isles who, like Saint Columba, saw this sea-girt kingdom as one world, binding what is now known as Scotland to Ireland. This was the fabled Kingdom of Dalriada. Joseph Beuys knew that its kings were

enthroned on the highest point of the Hill of Dunadd, as a vantage point overlooking the Valley of Kilmartin.

The 2016 exhibition, celebrating the life and art of Joseph Beuys must be regarded as a stepping stone to an academic research centre dedicated to the presence of Joseph Beuys in Scotland throughout the 1970s and '80s and the inspiration he found in the stuff and substance of its landscape. It would be an essential satellite to the building which must house, in perpetuity, the Demarco Archive as a large scale 'total art work' – a veritable *Gesamstkunstwerk*. The complex of national and civic museums and galleries with permanent collections dedicated to Joseph Beuys in Europe should thus be linked to what would become the world of Beuys in Scotland and in particular its Celtic traditions, uniting Scotland and Ireland.

My partnership with Joseph Beuys had to include all those I respected in the English-speaking art world in the early 1970s, when he was virtually unknown to that world. Chief among them at that time were David Baxandall, the Director of Scotland's National Galleries, and his colleague, Douglas Hall, the Director of the Scottish National Gallery of Modern Art. There was also Nicholas Serota who was, in the early 1970s, the Director of Oxford's Museum of Modern Art as well as Mark Francis who is now a Director of the Gagosian Gallery in London.

He and Sandy Nairne were 'Edinburgh Arts' participants. Sandy Nairne was until recently Director of the National Portrait Gallery in London. Tina Brown and Charles Stephens were then both Oxford University graduates. Charles Stephens wrote illuminating essays on Joseph Beuys long before well-established art critics

and historians were prepared to do so. Tina Brown became editor of *The New Yorker*.

Michel Pye, then a senior journalist for *The Scotsman* and later a well-established novelist, was the very first to write what became an historic essay on Joseph Beuys, accompanying him to Rannoch Moor on the first stages of the making of Beuys' masterwork *Celtic (Kinloch Rannoch) The Scottish Symphony*.

The *Guardian* art critics Caroline Tisdall and Cordelia Oliver became acknowledged experts on the genius of Joseph Beuys. George Oliver, Cordelia Oliver's husband and an outstanding press photographer, took historic photographs of the art of Joseph Beuys in Scotland as well as his fellow artists in the *Strategy: Get Arts* exhibition. His photographs were invaluable when used as the cover of the now highly-valued exhibition catalogue. John Gale, the celebrated *Observer* war correspondent wrote a thought-provoking article.

Joseph Beuys was most generous in collaborating with artists whilst in Scotland particularly Scottish artists such as George Wyllie, Rory McEwen, Alan Smith, Dawson Murray, Dawyck Haig, Alistair Park and Jimmy Boyle, as well as German artists such as Johannes Stüttgen, Ute Klophaus and Henning Christiansen from Denmark, Tim Emlyn Jones from Wales, Tadeusz Kantor from Poland, Marina Abramovic from the former Yugoslavia, Paul Neagu from Romania, Richard England and Mary de Piro from Malta, Li Yuan-chia from Taiwan, Jon Schueler and Tom Marioni from the United States, Kevin Atkinson from South Africa as well as Sally Potter, Jacky Lansley, David Tremlett and Patrick Reyntiens from England. Beuys also collaborated with museum and gallery directors and patrons such as Ulrich Krempel,

Jürgen Harten, Johannes Cladders, Georg Jappe, Karl Ruhrberg, Philomene Magers, Rune Mields, Saskia Bos, Rene Block, Anthony d'Offay, Heiner Bastian, James Harithas, John Stoller, Arnold Herstand, Giuseppe Panza di Biumo, Brigitte Lohmeyer, Peter Diamand, Nigel Greenwood, Magda Salvesen, Jennifer Gough-Cooper, Guy Brett, Nigel Gosling, Michael Spens, George Melly, Jack Burnham, Michael Shepherd and Alastair Mackintosh.

It should be noted that Joseph Beuys made manifest 11 art works in Scotland. In 1970 he presented *The Pack* and *Arena* as installations in Edinburgh College of Art and also performed *Celtic (Kinloch Rannoch) The Scottish Symphony* on the Moor of Rannoch and in the life room of Edinburgh College of Art. He also made the *Loch Awe Piece* on the shoreline of Loch Awe in Argyll.

In the Demarco Gallery's Melville Crescent 'Edinburgh Arts' Summer School space, he performed his 'Action' inspired by Anarcharsis Cloots in the form of *The Twelve Hour Lecture*. Also in 1973, at the Forrest Hill Poorhouse, he participated in the Cricot Two 'Action' of the Witkiewicz play, *Lovelies and Dowdies*, in collaboration with Tadeusz Kantor.

In 1974 in the Forrest Hill Poorhouse, in collaboration with Buckminster Fuller, he presented a six-hour 'Action' as a connection to the Demarco Gallery's 'Edinburgh Arts' *Black and White Oil Conference*. He also performed the *Three Pots Action* in the Poorhouse.

In 1976 at the Demarco Gallery's space in Monteith House, Beuys presented the sculpture by Jimmy Boyle entitled *In Defence of the Innocent*, thus taking the place of Jimmy Boyle who was in the Special Unit of HM Prison Barlinnie serving life imprisonment.

In 1980 he made the blackboard diptych entitled *Jimmy Boyle Days* and directed a three-day 'Action' at the Demarco Gallery in The Canongate as part of the 1980 'Edinburgh Arts' programme.

In 1981 he made the Poorhouse doors into a sculpture entitled *New Beginnings are in the Offing* in collaboration with George Wyllie and Dawson Murray. He also collaborated with John OR Martin to make three limited edition prints entitled *Beuys and Buckminster Fuller with Lady Rosebery*, one inspired by Greyfriars Bobby and another linking his two 'Actions', *Eurasian Staff* – inspired by the extreme eastern boundary of Europe – and *Celtic (Kinloch Rannoch) The Scottish Symphony* – inspired by the extreme western boundary of Europe in the Hebridean shorelines of the Kingdom of Dalriada.

Beuys also engaged in a dialogue with Dawyck Haig, a fellow artist and survivor of World War II, in Bemersyde Castle and in Dryburgh Abbey.

In December 1985, he made plans to return to Edinburgh to collaborate with Douglas Hall and make a return visit to Dalriada to explore the world of Fingal and his son Ossian with a view to a 'total art work'.

Richard Demarco, 2016

Joseph Beuys: Timeline

1921	Born 5 May in Krefeld, Germany. Spends his youth and adolescence in Kleve.
1940	Plans to study medicine, but drafted into the Luftwaffe.
1941–45	Serves as a Stuka pilot and is wounded five times. In 1943 is shot down over the Crimea, and his life is saved by Tartars. Wrapped in felt and fat to keep him warm, this experience informs much of his later work.
1945–46	Held at a British prisoner-of-war camp in Cuxhaven, Germany.
1947–51	Studies sculpture at the Staatliche Kunstakademie, Düsseldorf, under Joseph Enseling and Ewald Matare.
1952–54	Has a studio in Düsseldorf, and works as Matare's 'master pupil'. In 1953 his childhood friends, the Van der Grinten brothers, organise his first solo exhibition at their house in Kranenberg, near Kleve.
1954–55	Has a nervous breakdown.
1957	Works on the Van der Grinten farm in Kranenberg.
1959	Marries Eva Wurmbach.
1961	Appointed Professor of Monumental Sculpture at the Staatliche Kunstakademie, Düsseldorf. Moves to house and studio in Oberkassel district.

Has an exhibition at the Stadtisches
Museum Haus Koekkoek, Kleve.

1962–63 First involvement with the Fluxus
movement. In 1963 helps organise the
Festum Fluxorum Fluxus at the
Staatliche Kunstakademie, Düsseldorf.
Presents his first 'Action', *Siberian
Symphony*, 1st Movement, The
exhibition Joseph Beuys Fluxus is held
at the Van der Grinten's house.

1964 Performs the 'Actions' *Der Chef* and
*The Silence of Marcel Duchamp is
Overrated* in Düsseldorf. The latter is
broadcast live on German television.
Shows drawings and sculptures at
Documenta III in Kassel.

1965 Opens his first exhibition at the
Schmela Gallery, Düsseldorf with the
'Action' *How to Explain Pictures to a
Dead Hare*.

1966 Performs the 'Actions' *Eurasia II and
34th Movement of the Siberian
Symphony* in Copenhagen and
Manresa in Düsseldorf.

1967 Founds the 'German Students Party as
Metaparty' in Düsseldorf and begins
political activities. Performs the
'Action' *Eurasian Staff 82 min
fluxorum organum* in Vienna. First
major presentation of his work *Parallel
Process I* at the Stadtisches Museum,
Mönchengladbach.

1968	The Academy expresses no confidence in his 'Action' *I'm trying to set (make) you free*. Shows most of the work now in the collection of the Hessisches Landesmuseum, Darmstadt, at *Documenta IV*.
1969	Exhibition of his drawings at the Kunstmuseum, Basle.
1970	Joseph Beuys visits Scotland for the first time in order to plan his contribution to the *Strategy: Get Arts* exhibition of contemporary German art at the Edinburgh College of Art presented by the Demarco Gallery in collaboration with the Düsseldorf Kunsthalle.
	Richard Demarco leads him to the Moor of Rannoch and Argyll.
	Performs an 'Action' on Rannoch Moor which is filmed. Performs *Celtic (Kinloch Rannoch) The Scottish Symphony* at Edinburgh College of Art and shows *The Pack* as part of the *Strategy: Get Arts* exhibition. Founds the 'Organisation of Non-voters, Free Referendum'.
August 1970	Beuys installs *The Pack* (1969) in a corridor at Edinburgh College of Art together with photographic documentation of his performance-actions (*Arena*) in a large studio adjacent to where he performed *Celtic*

(*Kinloch Rannoch*) *The Scottish
Symphony* (26–30 August) in
collaboration with Henning
Christiansen and Rory McEwen.

1971 Founds the 'Organisation for Direct
Democracy through Referendum' and
the 'Committee for a Free Academy'.
His supporters occupy the
administration offices of Staatliche
Kunstakademie, Düsseldorf, protesting
against the restriction of student
admissions.

1972 Debates with the public for 100 days
at *Documenta V*. After occupying the
Kunstakademie offices for a second
time, is dismissed from his teaching
post without notice.

August 1973 Returns to Scotland to give a *Twelve
Hour Lecture – A Homage to
Anacharsis Cloots* as part of the
Demarco Gallery's 'Edinburgh Arts'
Summer School in Melville College.
Blackboards purchased by Dayton's
Gallery, Minneapolis.

1974 With Heinrich Boll founds the 'Free
International University for Creativity
and Interdisciplinary Research' (FIU) in
Düsseldorf. Performs with a live coyote
in *I Like America and America Likes
Me* at the René Block Gallery, New
York. Guest professorship at the
Hamburg Academy of Fine Arts.

Travelling exhibition of drawings *The Secret block for a Secret Person in Ireland*, including venues at the Museum of Modern Art, Oxford and the Scottish National Gallery of Modern Art, Edinburgh. Travels in Ireland holding discussions in Dublin, Limerick, Cork and elsewhere.

June 1974 *Three Pots* 'Action' in the Poorhouse, Forrest Hill, where Richard Demarco had presented Tadeusz Kantor's Cricot Theatre at the Edinburgh Festival 1972 and '73. *Three Pots* sculpture purchased by the Scottish National Gallery of Modern Art.

August 1974 Participates in Demarco Gallery's 'Edinburgh Arts' Summer School. Three hour lecture as contribution to *Black and White Oil Conference* in the Forrest Hill Poorhouse with Buckminster Fuller. Meets Jimmy Boyle as 'Edinburgh Arts' participant. *Coyote (I Like America and America Likes Me)* 'Action' documentation by Caroline Tisdall in the Poorhouse.

1975 Travels to Kenya.

January 1976 Beuys represents Jimmy Boyle in a press conference for Boyle's sculpture *In Defence of the Innocent* at the Demarco Gallery in Monteith House. Visits Boyle in the Special Unit, HM Prison Barlinnie, Glasgow.

1976	Stands as a parliamentary candidate. *Tramstop* exhibited at the Venice Biennale.
1977	Shows *Honey Pump at the Workplace* at *Documenta* vi. His 100-day 'Free International University for Interdisciplinary Research' includes a Northern Ireland workshop.
1978	Industrial tribunal declares his dismissal from the Academy in Düsseldorf illegal. Awarded the Thorn-Prikker Medal of Honour in Krefeld.
	Joseph Beuys attends Richard Demarco's lecture at the Düsseldorf, Kunstalle.
1979	Meets Andy Warhol. Parliamentary candidate for the Greens in the European Parliament elections. Represents Germany at the Sao Paolo Biennale and has a major retrospective exhibition at the Solomon R Guggenheim Museum, New York. Performs *Yes Now We're Going to Break off the Shit* in Berlin.
1980	Visits Edinburgh with other members of the FIU.
August 1980	In celebration of the 10th Anniversary of *Strategy: Get Arts*, Richard Demarco invites Joseph Beuys to define the spirit of German art in the '80s and he chooses to do so through his concept of the Free International

University. Like *Strategy: Get Arts* the exhibition is presented in collaboration with the Düsseldorf Kunsthalle and the German Ministry of Culture. It is presented as part of Demarco Gallery's 1980 'Edinburgh Arts' exhibition at Gladstone Court on the Royal Mile. Beuys goes on hunger strike because of Jimmy Boyle's removal from the Special Unit, Barlinnie, to Edinburgh's Saughton Prison where he is no longer able to continue his art. As a direct result of this 1980 Festival Exhibition, Joseph Beuys is commissioned by the Richard Demarco Gallery to make three suites of limited edition prints: *New Beginnings are in the Offing*, *Celtic (Kinloch Rannoch) The Scottish Symphony*, and *Joseph Beuys Meeting Buckminster Fuller*.

1981 Major exhibition of his work from private collections at the Städtische Galerie in Lenbachhaus, Munich.

August 1981 Beuys makes his last visit to Edinburgh to work on and install his *Poorhouse Doors* sculpture as part of the Scottish National Gallery of Modern Art's exhibition of works from the collection of the Mönchengladbach Museum, an exhibition originally planned by Johannes Cladders for the Demarco Gallery. The *Poorhouse Doors* were installed with the assistance of George

Wyllie and Dawson Murray and entitled *A New Beginning is in the Offing*.

1982 Participates in *Documenta* VII by beginning the *7,000 Oaks* project. Travels to Australia. Meets the Dalai Lama in Bonn.

1984 Travels to Japan.

1985 *Palazzo Regale*, his last installation, is mounted at the *Museo di Capodirnonte*, Naples.

1986 Awarded the Wilhelm Lehmbruck Prize. On 23 January dies of heart failure.

At the Edinburgh Festival, the Demarco Gallery presents a *Joseph Beuys Memorial* exhibition in Jeffrey Street.

1987 At the opening of *Documenta* VIII, Beuys's son, Wenzel, plants the last oak of the *7,000 Oaks* 'Action'.

During the Edinburgh Festival, the Demarco Gallery, in collaboration with the Arnolfini Gallery in Bristol and Caroline Tisdall, presents the exhibition entitled *Bits and Pieces* from the Beuys Collection of Caroline Tisdall.

1988 The Demarco Gallery, in collaboration with Peacock Printmakers, Aberdeen, presents an exhibition at the Collegium Artisticum, Sarajevo, of Scottish and international artists with a special reference to Joseph Beuys.

1990 At the Kelvingrove Art Gallery and Museum in Glasgow, there is an exhibition entitled *Beuys, Burns and Beyond* in collaboration with the Goethe-Institut in Scotland and George Wyllie, artist and past-President of the Society of Scottish Artists. This is part of Glasgow's exhibition programme as European Capital of Culture. There is also a conference which includes such experts as Kenneth White, Kenneth Simpson, Hans Joachim Verspohl, Shelley Sacks and an exhibition of three artists, George Wyllie, Merilyn Smith and Richard Demarco, all inspired by Joseph Beuys.

1992 The Demarco European Art Foundation presents an exhibition at the Ulster Museum to coincide with the AICA Conference in Ireland and Northern Ireland. The Demarco Foundation's Beuys Collection was presented in juxtaposition with the four Beuys blackboards which Beuys gifted to the Ulster Museum in 1974.

1994 At St Mary's School in Edinburgh, the Demarco European Art Foundation presents *Joseph Beuys in Scotland* – an archival display and art works in the form of testimonies by 38 Scottish artists including Rose Frain, Glen Onwin, Eileen Lawrence, George Wyllie, Ian Howard, Lys Hansen, Terry

Ann Newman, Arthur Watson,
Dawyck Haig, Will Maclean, Doug
Cocker and Bill Scott.

1995 Henning Christiansen and Ursula
 Reuter, in collaboration with George
 Wyllie, perform the 'Action' entitled *70
 Hammer Blows Against Warmongers*.
 It is performed in Edinburgh College of
 Art in the life room in which Joseph
 Beuys and Henning Christiansen
 performed *Celtic (Kinloch Rannoch)
 The Scottish Symphony* in 1970, as
 well as on Rannoch Moor beside the
 Joseph Beuys memorial sculpture of
 George Wyllie. This marked the 25th
 anniversary of *Strategy: Get Arts*.

1997 'Manresa' symposium at St Mary's
 School on the subject of Joseph Beuys
 in Scotland and his sculptures and
 'Action' entitled *Manresa* at the Alfred
 Schmela Gallery in Bonn in 1964. Fr
 Friedhelm Mennekes (SJ) with
 Professor John Haldane (St Andrews
 University), Jimmy Boyle and Alastair
 MacLennan.

1999 Programme of live music and
 exhibition at Edinburgh University's
 School of Architecture's Matthew
 Gallery, including Demarco Archive
 focused on Beuys.

2000 In the Millennium Year, Kingston
 University, in collaboration with the

Demarco European Art Foundation, presents the exhibition *70/2000 on the Road to Meikle Seggie*. This exhibition subsequently tours to the Edinburgh City Art Centre during the Edinburgh Festival 2000, and then, in 2001, to the National Gallery of Lithuania in Kaunas, and later to Oxford Brookes University and to the John Ruskin Museum at Brantwood in Cumbria.

2004 Christa-Maria Lerm Hayes presents a conference in Dublin, together with a major exhibition at the Royal Hibernian Gallery, on the theme of 'Joyce and Beuys'.

2007 An exhibition and conference at the University of Ulster in Derry in collaboration with Dr Victoria Walters, Christa-Maria Lerm Hayes and Martyn Anglesea, inspired by Joseph Beuys in the Celtic world. Richard Demarco plants an oak tree in the Ulster University's campus grounds, together with a basaltic stone, in memory of Joseph Beuys.

A Highland Decade exhibition at the Royal Scottish Academy, with special focus on Joseph Beuys and 'Edinburgh Arts' (1970–80).

Exhibition focused on Joseph Beuys at the Pittenweem Arts Festival, Fife.

2008 David and Trish Gibson present an exhibition in collaboration with the DEA Foundation entitled *The D.I.Y. Show* during Glasgow's International Festival of the Arts. This includes Richard Demarco's event photographs of Beuys.

2010 In collaboration with Ian Hunter and Celia Larner (Littoral Arts Trust), an exhibition inspired by Joseph Beuys at the Bogside Artists' Gallery in Derry.

Arthur Watson, artist and now President of The Royal Scottish Academy, with particular reference to the exhibition of Joseph Beuys at the Academy – entitled *Ten Dialogues – Richard Demarco and the European Avant-Garde*.

2011 Trevor Thorne presents an exhibition at Southampton Solent University celebrating the work of Joseph Beuys in collaboration with the Demarco Gallery from 1970 to 1986. The exhibition relates the art of Joseph Beuys to that of Paul Neagu (Romania), Yvette Bozsik (Hungary), Ian Hamilton Finlay (UK), John Calder (UK), Tadeusz Kantor (Poland) and Jimmy Boyle (Scotland).

2012 David Gibson and the DEA Foundation present an exhibition at the Foundation's gallery in Craigcrook

Castle entitled *Venus + Beuys + Demarco*. Artists are invited to make A5 pencil drawings with reference to Beuys and his use of a Venus 2H pencil.

2013 In the Lookout Tower Gallery in Aldeburgh, Suffolk, in collaboration with Caroline Wiseman and Chris Wainwright during the Aldeburgh Festival, an 'Action' entitled *What has to be done?* on the South Beach in homage to Beuys. This is an updated version of the 'Action' made by Chris Wainwright at the megalithic temple of Hagar Qim on Malta under the aegis of the Demarco Gallery's 1978 'Edinburgh Arts' programme.

2015 The Museum of Contemporary Art in Krakow (MOCAK) presents the exhibition *Beuys, Kantor, Demarco*, curated by Jozef Chrobak and Martyna Sobczyk.

2016 Two exhibitions – one at Summerhall, including a special large-scale watercolour by the DEA Foundation commissioned by Hugh Buchanan, and the other at the Scottish National Gallery of Modern Art which is entitled *Richard Demarco and Joseph Beuys – A Unique Partnership*.

This exhibition involves the Demarco European Art Foundation in presenting a programme of symposia in various

locations in Scotland and Yorkshire,
and a five-day symposium and
exhibition in Wroclaw as part of the
2016 European Capital of Culture, and
in nearby Sokolowsko, in honour of
Richard Demarco's 'Edinburgh Arts'
programmes dedicated to cultural and
academic dialogues between such
European countries as Poland,
Germany, Romania and the Former
Yugoslavia; with special reference to
Beuys' exhibition at The Foksal
Gallery in Warsaw and in the Muzeum
Sztuki in Łódź.

Beuys in Scotland

The *Documenta* exhibition, in Germany in the summer of 1968, is forever in my memory encapsulated in one magical moment, still in clear focus in my mind's eye. I see a large exhibition room full of long tables and strange objects which suggested the aftermath of a highly significant and complex scientific experiment. At a distance an extraordinary man unexpectedly imposed his presence upon the room and everything in it by examining and adjusting the objects with precise and dignified movements. He was dressed in a multi-pocketed grey fisherman's waistcoat, a white, open-necked shirt, and blue jeans. Sitting squarely on his head, half-obscuring his sallow-complexioned face was a grey fedora hat, incongruously and splendidly formal.

On a lengthy tour of the United States, immediately following my visit to the *Documenta* exhibition, the image of Joseph Beuys from Europe persisted. I believed then that I had seen signs of the first significant shift of energy from the New World back to the Old, to a precise point where the Rhine–Ruhr area was the centre of the post-war economic revival.

When I eventually did get to know Beuys, in the winter of 1970, he was fully occupied with half-a-dozen friends, who filled the small studio that served as reception area and office, an extension of the unobtrusive house in which he lived with his wife Eva and two young children, Jessyka and Wenzel, in the Oberkassel area of Düsseldorf, I wondered what I could offer that would make him concentrate his attention upon Scotland, the very periphery of the international and contemporary art world. I decided not to ask him to make a new and special art

work at this time, but to concentrate instead upon the simple, obvious and unique nature of Scotland's physical beauty defining the seagirt western extremity of Europe.

Over ten minutes, I showed Beuys a collection of post-cards of Scotland. He examined each and every card. Their subject matter was a mixture of heather and heath; mountain stream and waterfall; forest and field; deer, sheep and highland cattle; the midsummer sunset over islands; Celtic and Pictish standing stones. After a long silence, Beuys remarked: 'I see the land of Macbeth; so when shall we two meet again? In thunder, lightning or in rain?' On a thundery May day soon after this, he arrived at Edinburgh airport.

Beuys was eager to experience the Celtic heartland of Scotland, on the road to the Hebridean Isles, and he wished to incorporate his personal experience of Scotland into the essence of his work. I led him on the road once traversed by Roman legionaries, Celtic saints and scholars, cattle drovers and shepherds, I know it as 'the Road to Meikle Seggie'; one of Scotland's 'lost' villages and, indeed, the road to all the lost human settlements which have slipped off our modern maps of Europe.

The road leads to the Atlantic extremity of Europe, which the Celts acknowledged as the 'Land of the Ever Young' in which present time and eternity intertwine. It complements that other extremity of Europe in the eastern frontier land of the Tartars, where Beuys had narrowly escaped death during the Second World War in the wreckage of his Luftwaffe bomber, his near-mortal wounds had been healed by the Tartar's understanding of the therapeutic properties of fat and felt, materials that feature so significantly in his art.

At our fateful first meeting in Germany, Beuys had accepted my invitation to Scotland because of his knowledge of Shakespeare's *Macbeth* and his interest in the mythology of the Celts as expressed in the *Tales of Ossian*, the son of the legendary Fingal. He was well aware of Felix Mendelssohn's journey to the Hebrides and his musical interpretation of Fingal's Cave, inspired by the basaltic rock formation of the Island of Staffa, close to the sacred island of Iona, where St Columba persuaded the Druids to replace their pagan worship of the oak tree with Celtic Christianity. The symbolism of the oak and basaltic stone were to provide inspiration for Beuys' art-making in both Scotland and Ireland.

When Beuys returned to Scotland for the Edinburgh Festival in August 1970 he was accompanied by artists from the burgeoning Düsseldorf school, many of them his former students. They made site-specific works for an exhibition with the palindromic title *Strategy: Get Arts*. Beuys spearheaded the exhibition's attack on out-moded cultural attitudes. He questioned to the core the Edinburgh Festival's concepts, which rigorously separated visual art activities from theatre, music, dance and even film programmes. Beuys' main contribution was a concert, a seven-day 'Action', in collaboration with the Danish sculptor/composer Henning Christiansen. Entitled *Celtic (Kinloch Rannoch) The Scottish Symphony*; it was pre-sented in one of the large studios of Edinburgh College of Art in relation to an adjoining room containing innumerable framed photographs of his previous 'Actions' and artworks. This was the first exhibition of a work later entitled *Arena*, now on permanent display in New York. We had difficulty persuading the college authorities to allow Beuys to install *The Pack*, his

installation in the form of a Volkswagen bus together
with its attendant herd of sledges, inside the college
building. He was, after all, a teacher of art. We won.

Joseph Beuys was to return many times to Edinburgh,
out of his love for Scotland and his desire to see the
ancient Celtic cultural origins of Europe revitalised within
contemporary art language. In 1973, 1974 and 1980
he participated in the Demarco Gallery's experimental
'Edinburgh Arts' summer school, which was modelled
on Black Mountain College and Nova Scotia College
of Art. I placed Beuys in a teaching role alongside
Buckminster Fuller, Hugh MacDiarmid, art critics,
historians and theorists, East European artists such as
Paul Neaqu, Tadeusz Kantor, Magdalena Abakanowicz
and Marina Abramovic, and such British art world
luminaries as Roland Penrose, Sandy Nairne, Mark
Francis and Caroline Tisdall.

I remember Beuys as a solitary figure by the water's
edge on the shores of Loch Awe during his first visit to
Scotland in 1970, searching for bits and pieces of earth
and wildflowers, and standing in golden light on a pier
watching the seagulls swoop and circle over the Oban
fishing fleet; in 1974 in dicourse with Buckminster
Fuller during the Demarco Gallery conference which
questioned the economics of Scotland's rapidly expan-
ding North Sea oil industry; in 1976 standing in for
Jimmy Boyle, the personification of the community of
prisoners and prison officers; in the Special Unit of
Glasgow's Barlinnie Prison, during Boyle's sculpture
exhibition entitled *In Defence of the Innocent*. In 1980,
again concerned with and for Jimmy Boyle, he went on
hunger strike. Shortly afterwards the Demarco Gallery
lost its financial support from the Scottish Arts Council

for 'bringing discredit to the meaning of art in Scotland'. So began a period of endurance for the Gallery, which survived only through the generosity of donations from its supporters. Chief amongst them was Beuys, who returned to Edinburgh to transform the doors of the Gallery's former exhibition space in the Forrest Hill Poorhouse into a sculpture, eventually acquired to the benefit of the gallery appeal, by the Museen der Stadt Mönchengladbach. As always with everything Joseph Beuys did, art became manifest through the power of friendship, loyalty and love.

Beuys is now universally regarded as one of the great artists of the 20th century. More accurately he should be regarded as one of the first artists to signal the 21st century. His credo was that 'everyone is an artist'. He meant that every human being is born with the potential to be creative, that human creativity is the essence of health and well-being and that every human life should be considered as a work of art. He certainly treated everyone he met as a fellow artist, no matter if they appeared to be without artistic merit and even those hostile to art in any shape or form.

His art demands a transformation in the mind of anyone who wishes to contemplate it. In 1991, five years after his untimely death, Beuys was honoured with an exhibition at the Watari Museum in Tokyo. In the publication that accompanied the exhibition, Noriyuki Ueda, the Japanese art critic, stated that when one 'stands before Beuys and his work, one is empowered and enters into a bond with Beuys, acting in concert with him. If this crucial relationship is ignored, all discussion becomes pointless'.

The exhibition was of a unique collection of prints

and multiples, which Beuys entitled *Polentransport*, in English, simply *A Parcel for Poland*. Along with his art works, he added 20 cases of German wine and his physical presence in Poland. This gift resulted from a splendid example of Beuys' theory of 'social sculpture'. The particular 'Action' (he preferred 'Action' to 'Happening') had the express purpose of identifying Germany with Poland in 1981 when Poland was suffering the indignities of the Cold War, including the terror of martial law. It involved Beuys, accompanied by his wife Eva and their daughter Jessyka and son Wenzel in a journey by road, which took them and their gifts across the borders between West and East Germany to Łódź in Poland, a city with a significant history of arts patronage. Jewish patrons had left a priceless legacy to the Łódź Museum of Art in the form of an outstanding collection of Constructivist paintings and sculptures from both Poland and Russia. In the post war period, this collection was brought up to date with art collected by the renowned museum director, Ryszard Stanisławski. It was to the Łódź Museum that Beuys drove along the route that had brought countless German Jews to the gates of Auschwitz.

This 'Action' had a particular significance for me because both Beuys and Stanisławski had committed themselves to Edinburgh and the Demarco Gallery. The gallery had made a point of bringing both German and Polish *avant-garde* artists to the Edinburgh Festival in the early '70s.

Joseph Beuys was my friend. He was also my patron and collaborator. He knew I would never present his work within the context of an official gallery space, which included my own. I would offer him only the challenge

of the Edinburgh Poorhouse at Forrest Hill, the Special Unit of Barlinnie Prison, the quintessential Scottish wilderness of the Moor of Rannoch, the working studios of Edinburgh College of Art, their floors bespattered with the painted marks of countless generations of art students, the gymnasium of Melville College, or the 'Road to Meikle Seggie', my version of the road leading to the land of Fingal and Ossian.

Beuys believed that art is born out of a system of economics, focused not on politics or consumerism but quite simply on human hopes and aspirations, express-ing the tripartite dimension of the physical, intellectual and spiritual realms. Despite his physical death in 1986, his spirit lives on in his great sculpture of the *7,000 Oaks*. All were planted, together with 7,000 basaltic stones, in homage to the Celtic symbolism of the sacred oak, and the world of Fingal on Staffa. The Oaks are beginning to grow towards maturity now, blessing the city of Kassel in Germany. He asked me to consider planting a *7,000 Oaks* sculpture in Scotland. That is a challenge not just for myself but for all those he met as artists. It means that to honour Beuys properly, it is not enough to judge him solely by the many exhibitions of his works presented by museums of art throughout the world. These exhibitions might suggest that the life's work of Joseph Beuys is completed by his death. He lives on through his *7,000 Oaks*. They are very much alive and will continue to enhance the lives of yet unborn generations as prime examples of the art of a new Millennium.

Richard Demarco, 2016

Richard Demarco's personal experience
of the reality of *Strategy: Get Arts*

Robert Filliou asked me to play his 'Vocational Game', his contribution to *Strategy: Get Arts*, on the first day of the exhibition. I glued eight small, cube-shaped pieces of wood onto the strawboard base he provided, knowing that whatever I did I should make clear that the exhibition had emerged from the world within Edinburgh that had created the Traverse and the Demarco Gallery. Whatever this world is it cannot be defined as specifically Scottish; it is maintained by those who instinctively need the cosmopolitan life. For me the exhibition was a central point from which radiated all manner of ideas and developments affecting and being affected by this world which gives me hope for the future of living so far north in the British Isles.

I chose to make each cube a step in the ladder, which began in the bottom right hand corner and ended in the centre point of the board, the ninth and final step representing the reality of *Strategy: Get Arts*. The first cube represented Edinburgh, my birth place and my place of work; the second represented the Edinburgh Festival, which had taught me respect for all the arts within an international framework. The third and fourth represented my respect for tellers of fairy tales such as Robert Shure's *Twink* and Antoine de Saint Exupery's *Le Petit Prince*. They had kept me sane through ten years of school teaching and too close contact with the academic ways of learning. The fifth cube was the Traverse Theatre, which first enabled me to truly express myself through an art form. The sixth represented the Demarco Gallery, born out of the

Traverse, and the seventh was the *Edinburgh Open Hundred*, the first exhibition to introduce the contemporary visual arts into the structure of the official Edinburgh Festival. In the space where the eighth cube should have been was a question mark which represented the intangible, mysterious and magical forces, defying rational thought, which thereafter provided the sources of inspiration which brought about my awareness of the Düsseldorf art scene. I could have added another cube after that representing my 1970 visits to West Germany and the States, which gave me concrete proof that the time had come for the long dead dialogue between the American and European art worlds to be reopened.

Robert Filliou was most pleased when those who played his game revealed a strong personal reaction to the exhibition itself. I chose to directly relate myself to the exhibition and use the game to reassure myself that the long years of waiting for such an event had in no way been wasted, even those years spent teaching art, which had led me to lose faith in the very experience of art. Whilst playing the game I saw myself still a teacher in the guise of a gallery director and certainly *Strategy: Get Arts* had much to do with art education. It was, after all, presented in an art college rather than in a gallery. It was the art lesson I had always wanted to teach, or indeed to be taught. I wanted to challenge the function of an art college in the 'Seventies'. Indeed, it should have remained as part of the building for the students to begin their new session with the experience of it. Those students who helped to install the show became deeply involved and defended it against the criticisms of 'the cognoscenti' who were afraid to relax

and enjoy it. It was perhaps most of all an offence
against the sense of good taste of those Scots who by
tradition define art always in aesthetic terms. The
Netherlands Dance Company felt reassured by the
exhibition. By instinct they knew they should be
collaborating with these Düsseldorf artists. This is
what can happen at a festival of all the arts. Surely,
inevitably, the visual arts will be integrated with the
more readily accepted arts forms of music and drama.

My intention was to have the artists integrate the
building itself into their ideas of the exhibition. No
architect or exhibition designer was employed. The
building remained a 'non-gallery', a proper place to
house a 'non-exhibition', perhaps the first Edinburgh
had experienced which was in no way retrospective. It
was an exhibition 'in progress'. It changed in character
from day to day. It did not attempt to emphasise a
certain style or school. It did not attempt to answer
questions, rather it posed them: Why Düsseldorf? Why
an emphasis on concerts, films, environments, and even
a banquet (*The Banana Trap Dinner* by Daniel Spoerri)?
Were Henning Christiansen, Joseph Beuys and
Friedhelm Dohl providing the most *avant-garde* music
of the Edinburgh Film Festival? Were the films of Lutz
Mommartz extending beyond the ideas of the most
experimental film makers invited to the Edinburgh
Film Festival? Were Gunther Weseler's breathing objects
a more complete dramatic statement than *Orlando
Furioso*? Should the exhibition have found a London
home – at the Hayward, the Tate, or the LCA, or perhaps
the Round House? Well over half the 35 artists were
invited to Edinburgh. Their physical presence was
necessary. It was Stefan Wewerka who finally decided

to scatter his wounded chairs all over the main staircase. It was Gunther Uecker who chose the door that would bang open and shut once every ten seconds most dramatically. It was Joseph Beuys who decided that his sculpture *The Pack* should finally be at rest in an obscure corridor without any special lighting arrangements. It was Klaus Rinke who came to the conclusion that all the visitors should be confronted by a jet of water squirting at them on eye level from within the main entrance. This water sculpture commented on the exhibition's playful and yet threatening nature, as did Andre Thomkins' palindrome which hung above the entrance in the form of a banner.

The 1970 Festival was decidedly experimental in the eyes of the official Festival Committee. The young were wooed with the rock musical *Stomp* – which with the Theatre Libra's *Orlando Furioso* proved that a converted ice rink could work better than a theatre for large scale dramatic events, inviting audience participation. With such competition from music and drama, the visual arts could hardly have done without *Strategy: Get Arts*.

It was the first year that the world's second oldest established Film Festival was almost destroyed by the question of censorship. The letter of the law was used to ban films for not having British Film Board certificates. An alerted police force felt obliged to confiscate all the films from *Strategy: Get Arts*. When does a film become an 'art object' in itself and worthy of representing a serious artist in an exhibition? The national and local press, radio and television were more than generous with their coverage of the exhibition. Police intervention aroused the interest of the layman. It was the subject of editorial comment in the *The Scotsman*.

It became a subject for popular discussion. Beuys was right, 'the Germans had finally come by night – by sledges'. Certainly they had come before Edinburgh had expected them; but this timing was vital to the final impact, it was part of the madness. I had always wanted an exhibition which would restore my faith in the activity of the visual artist in 20th century society, and which would help redefine the role of the gallery director. I had looked for an exhibition which would emphasise the artist's role as a powerful defender of the truth inherent in fairy tales and as a magician able to revive our sense of wonder. I wanted an exhibition which would free the artist, if he wished, from the responsibility of making master works, revealing more clearly his act of creating and his acceptance of his role as a performer involving every new means of communication with the so-called layman. I wanted an exhibition which would weaken the spirit of materialism, from which more than ever the artist must rescue us. The Düsseldorf artists gave me that exhibition.

I have always imagined what would have happened if Alexander Reid had actually gathered all the artists he knew in the Paris of 'the eighteen seventies' and presented them in Edinburgh before they had been truly discovered by the French. It would have been an utterly foolhardy act of faith which Edinburgh needed then as much as it does now. I was grateful to the Patron Saint of gallery directors who allowed me to present Edinburgh, a century later, with the full impact of the artists of Düsseldorf, a city which well deserves the title 'The Paris of the Rhine'.

Richard Demarco, for the September 1970 issue of *Pages*

7,000 Oaks: Richard Demarco Interviews Joseph Beuys

RICHARD DEMARCO

Your exhibition at the Anthony d'Offay Gallery strikes a sombre note underlined by the title: *Dernier Espace avec Introspecteur*. It was conceived in 1964 around the time of your first exhibition at the age of 43 with which it shares, and I'm quoting here, 'a predilection for certain angles and images'. This London exhibition was first presented in Paris in January 1982. The title could be misunderstood, but in Caroline Tisdall's catalogue she makes the point that 'it has not to be interpreted as a personal statement about the artist's demise, it has rather more to do with reflecting a feeling about the world'. I know from the conversation we had here tonight in London that your feelings about the world have lead to you to consider making a sculpture on a gigantic scale, and could be involving you in a personal expression of positive and optimistic energy at *Documenta* this summer, and will be entitled appropriately for this, the seventh *Documenta*, *7,000 Oaks*. It will be a celebration of many things, including the life of Jean Giono, the French writer who told the story of Elzéard Bouffier, the French shepherd who, like you, believed in the importance of planting oak trees. First of all, now that I've said that, I would like you to tell me how you can see a link between the present exhibition and this next step that you will take, this major work involving the planting of 7,000 oak trees at the *Documenta* in Kassel. You see it as a natural and inevitable step linking the world of the artist with that of the ecologist and naturalist. You will concentrate all

your energy on this and in some way relate to this as a sculpture, involving very powerfully, from my view-point, the dimension of time.

JOSEPH BEUYS

It is right, and you see already, in this title, the words 'last space' appears, in a relation to time. This is not as demise for my doings. It puts a kind of line under my so-called called spatial doing in so-called environments. I want it principally to mark the finish of this kind of work. I wish to go more and more outside to be among the problems of nature and problems of human beings in their working places. This will be a regenerative activity; it will be a therapy for all the problems we are standing before... that is my general aim. I proposed this to Rudi Fuchs when he invited me to participate in the *Documenta*. I said that I would not like to go again inside the buildings to participate in the setting up of so-called artworks. I wished to go completely outside and to make a symbolic start to my enterprise of regenerating the life of humankind within the body of society and to prepare a positive future in this context. I think the tree is an element of regeneration which in itself is a concept of time. The oak is especially so because it is a slowly growing tree with a kind of really solid heartwood. It has always been a form of sculpture, a symbol for this planet ever since the Druids, who are called after the oak. Druid means oak.

They used their oaks to define their holy places. I can see such a use for the future as representing the really progressive character of the idea of understanding art when it is related to the life of humankind within the social body in the future. The tree planting enterprise

provides a very simple but radical possibility for this
when we start with the *7,000 Oaks*.

DEMARCO

Why 7,000, Joseph?

BEUYS

I think it is a kind of proportion and dimension, firstly
because the seven represents a very old rule for planting
trees. You know that from already existing places and
towns. In America there is a very big town called Seven
Oaks, also in England at Sevenoaks. You see that seven
as a number is organically, in a way, related to such an
enterprise and it matches also the seventh *Documenta*.
I said that seven trees is a very small ornament. Seventy
is not bringing us to the idea of what I call in German
Verwaldung. It suggests making the world a big forest,
making towns and environments forest-like. Seventy
would not signify the idea. Seven hundred again was
still not enough. So I felt 7,000 was something I could
do in the present time for which I could take the
responsibility to fulfil as a first step. So 7,000 oaks will
be a very strong visible result in 300 years. So you can
see the dimension of time.

DEMARCO

It is beyond your lifetime and beyond the dimension of
20th century...

BEUYS

Surely...

DEMARCO

... or even the contemporary art world and you will see
this as a first step...

BEUYS

I see it as a first step because this enterprise will stay forever and I think I see coming the need for such enterprises: tree planting enterprises and tree planting organisations, and for this the Free International University is a very good body.

DEMARCO

You can see young people all over the world becoming an army of helpers.

BEUYS

Right.

DEMARCO

All over the world?

BEUYS

Surely.

DEMARCO

You can see oak planting on the hills of Scotland or Wales...

BEUYS

And Sicily and Corsica and Sardinia.

DEMARCO

You can see the hillsides around Belfast beginning to be covered.

BEUYS

Everywhere, everywhere in the world... also in Russia... there are too few trees... Let us not speak about the United States which is a completely destroyed country...

DEMARCO

It is a sadness, isn't it, in our time that it is the United States which is growing rockets, and nuclear weaponry, rather than trees. Now you will make this statement to counterbalance this, in the middle of Kassel. Can you describe this enterprise more precisely?

BEUYS

I will start in very difficult places in the centre of the town. There the places are very difficult because there are already coatings of asphalt and stone slabs with infrastructures of electrical things and the German Post Office. In the centre of the town the planting of trees is most necessary for the people that live there within an urban context. There the planting of the trees will also be most expensive. The whole thing I guess will cost about three million German DM...

DEMARCO

And who will provide this money? You will have to work with the city fathers.

BEUYS

Yes, but they will not give money... the city will cooperate in so far as they will support our activities with tools.

DEMARCO

And gardeners...

BEUYS

... and vehicles sometimes, but principally I took the responsibility for all of the money problems. I will fulfil this thing and ask many different people for support. I have received already help for the start of this thing, so for this year I have enough money to buy the stones

because every tree is marked with a basaltic stone. It's a natural form which need not be worked on as a sculpture or by stone masons. The stone is similar to what you will find in the basaltic columns of the Giant's Causeway, but more triangular in shape with five, six, or seven angles or irregular angled stones which come from the volcanoes...

DEMARCO

Will they come from the volcanoes around Kassel?

BEUYS

It is very organic because this nearest volcano to Kassel is only 30 kilometres from the centre of the town. It is very natural to take the stone to the place where I will plant the trees.

DEMARCO

What will be the date of the first planting?

BEUYS

It is already done...

DEMARCO

It is, already done...

BEUYS

I planted the first symbolic tree in the centre of the Friedrichsplatz. That's on the axis of the main building for the *Documenta* exhibitions and on the right side of this tree, there is one stone already deposited. When the last of the 7,000 stones will disappear from this place it will say that the last of the 7,000 *Oaks* is planted. That will be, maybe in three years...

DEMARCO

That will be for three years so that will last until the next *Documenta*.

BEUYS

That's true…

DEMARCO

Can you tell me, Joseph, just before we finish, how this tree project will allow you to continue your work on a new and wider dimension? This is a new dimension… it is a new step for you.

BEUYS

It is a new step for me, this working with trees. It is not a real new dimension in the whole concept of the metamorphosis of everything on this earth and of the metamorphosis of the understanding of art. It is about the metamorphosis of the social body in itself to bring it to a new social order for the future my comparison with the existing private capitalistic system and state centralised communistic system. It has a lot to do with a new quality of time. There is another dimension of time involved, so it has a lot to do with the new understanding of the human being in itself. It has to make clear a reasonable, practical anthropology. It is also a spiritual necessity which we have to view in relation to this permanent performance. This will enable it to reach to the heart of the existing systems – especially to the heart of economics – since the wider understanding of art is related to everybody's creative ability. It makes it very clear and understandable to everybody that the capital of the world is not the money as we understand it, but the capital is the human

ability for creativity, freedom and self-determination in all their working places...

This idea would to a neutralisation of the capital and would mean that money is no longer a commodity in the economy. Money is a hill for law, for rights and duties you know... it will be as real and will lead to a democratic bank system...

DEMARCO

It will, in fact, bring employment...

BEUYS

In fact, it will organically prohibit every kind of unemployment, and organically it will stop inflation and deflation. This is because it deals with the rules of organic money flow. This makes clear that all these interpretations of the future, especially thee interpretations of time, have a lot to do with a new understanding of the human being as a spiritual being. If you have the spirit in focus, you have also another concept of time... you see time on earth is a physical reality. It takes place in space so it is the space/time relation which Einstein is speaking about. This already gives a kind of allusion to another dimension, but I think this other dimension is something we have still to detect. When I say we have still to detect it, it has already been detected. It is there as one dimension in my work which I show in the Anthony d'Offay Gallery. This is the warmth quality...

DEMARCO

The quality of warmth.

BEUYS

This dimension is, in fact, another dimension that has nothing to do with the space and time relation. It is another dimension which comes to exist in a place and which goes away again. This is a very interesting aspect of physics, since until now most physicists are not prepared to deal with the theory of warmth. Thermodynamics was always very complicated stuff. Love is the most creative and matter-transforming power. You see in this context it is very simply expressed. Now it is not shown in very interesting diagrams which one could also bring to this discussion... But to promote this interest for all these necessities to the real anthropology and not this fashionable way of speaking about anthropology... in this relationship I start with the most simple looking activity, but it is a most powerful activity; it is planting trees.

London, 27 March 1982

Ex Cathedra

Claire MacDonald, Guest Editor of *Performance* maga-
zine special 50th issue – 1987 writes:

> Richard Demarco occupies a unique and seminal position
> in the history of Performance Art in Britain. He was the
> first in this country to mount performances by Joseph
> Beuys and Tadeusz Kantor amongst many others. Here he
> discusses the influence his home city of Edinburgh has
> had on him and the artists he has worked with there.

RICHARD DEMARCO

'Ex Cathedra' is the way in which the Supreme Pontiff,
the Bishop of Rome, speaks to that part of the world
defined by the Christo-Judaic culture into which I was
born and from which developed the concept of the
modern city. This culture has given the world the atom
bomb to contend with, but to offset the negative
implications of that, it has also given what is generally
known as the spirit of *avant-gardism* in the 20th
century art through music, dance and the visual arts.

Born as I was in the last years of that age of religious
faith which still existed in Europe more or less halfway
between the two World Wars, I was always in awe of
Rome, that city from which a human being could be
given the divine power of speaking 'ex-cathedra'. My
father's family name suggested that my forebears were
followers of 'Marcus'. I often wonder if they followed
him to Scotland, and if he was associated with that
Roman legion that managed to get itself thoroughly
lost in the Scottish Highlands. They had originated in
fact from the province of Frosinone just 60 miles south
of Rome. My father was rightly proud of his Roman
origins. They represented an imperial power strong

enough to mark its extreme north-western boundary
by a line connecting the estuaries of the rivers Forth
and Clyde called the Antonine Wall. This was the land-
scape to which my father's parents and countless other
Italian families had been inextricably drawn in the last
years of the 19th century. I had the sense of living on a
periphery all the days of my youth. I knew I was born
in Edinburgh, a city which marked the site of a kingdom
opposed to encroachment from an imperial power, the
kingdom ruled by a king called Edwin, linking what is
now called Northumbria with the Lowlands of Scotland
and which was doubtless associated through a potent
mixture of history and mythology to Arthur, that arch
enemy of Rome, the once and future king of all the
Celtic peoples of Europe. To this day, his name endures
in the form of a magic mountain which dominates the
centre of Edwin's capital or 'borough': the mountain is
called 'Arthur's Seat'. It is in fact a grass-covered hill
almost 1,000 feet high, but, because of its peculiar and
perfectly proportioned shape, it is easy to imagine it as
the site of that city of perfection associated with the
name 'Camelot'. It is formed by nature with extra-
ordinary accuracy and refinement to look like a recum-
bent lion. It has always been for me one of the wonders
of the world, the equal in its mystery and beauty to the
Sphinx of Egypt. All that is left nowadays of this 'Seat
of Arthur' are rows of terraces cut into the south-
eastern slopes.

Long after Arthur's reign, the medieval city of Edin-
burgh grew around an outcrop of volcanic rock which
forms the stuff and substance of the magic mountain.
The outcrop now known as Castle Hill was obviously
the perfect place for Edwin's successors to build their

citadel, around which a city could form itself. Little did I realise, born and bred as a citizen of Edinburgh, that I was being influenced daily by what could be considered arguably as the most beautiful and magnificent city site in all of Northern Europe. I had been taught to consider it as the Modern Athens, a title it had earned for itself in the period of the 19th century Enlightenment in Scotland, but knowing as I did, that it was built on seven hills, I preferred to think of it as the Northern European equivalent of Rome, for it was to me, even as a child, a city undeniably and proudly able to define the culture of Europe's north-western periphery, the necessary complement to Rome as the ultimate metropolitan centre of Europe's Mediterranean culture.

My Roman Catholic education taught me to see the pagan power of Rome transformed to facilitate the spread of Christianity throughout the length and breadth of Europe and in spite of the extreme form of Protestantism represented by John Knox, the leader of the Reformation in Scotland, that bedrock of Scotland's cultural heritage was irreversibly Catholic. Such an education was inextricably linked with the profound mysteries of orthodox religious ritual and the fact that all time in Europe was measured in relation to the death of Christ upon the Cross of Calvary. As an altar server and chorister, I had personal experience of a world of theatre on a grand scale when it came to the celebration of the great Christian feasts of Christmas and Easter. Every season of the year and every human emotion was taken into account in the sound of 8th century Gregorian chant and in the words of the *De Profundis* and in the *Litanies of the Saints*. The spoken word took upon itself an undeniably poetic dimension

because it was beyond the limitations of the vernacular connotation. Latin as a language was meaningful to me as a form of music. There were the sensual pleasures in the smell of incense and burning candles and in the colours of the priest's vestments and altar adornments. White and gold, green and purple and black were colours which helped me to know with delicate precision each season of the year and the significance of the passing hours of each day.

It was precisely because Edinburgh was such a great distance from Rome that I had felt a deep longing to travel from the European periphery to its centre in the spirit of a pilgrim. I cannot think of a time when I did not want to be an artist of some sort and I felt in my child's heart that my parents spoke the truth when they said that all great art and artists came from Italy and that even Paris and the French culture which they admired was built upon the principles of the Italian Renaissance.

The war years made it difficult for me to imagine myself experiencing the continental culture which my parents embodied. My whole childhood was blighted by the role that Italy was obliged to enact in world affairs until peace finally came. In 1949, the last year of my schooldays, I was able to get as far as Paris, the capital city even then for the world's artists containing, as I imagined, a fountainhead of truth from which aspiring art students could drink their fill and thus claim a place in the post-war international art world.

At the end of my first year at Edinburgh College of Art, wishing to celebrate my 20th birthday in relation to the worldwide celebrations of the Holy Year of 1950, I embarked, in the company of my father and 30 other

pilgrims, on my first journey to Italy and to Rome. We travelled by train, ferry and bus, through Paris, across the Alps to Rome and when I first experienced the sight of a vast crowd assembled within St Peter's Square to receive the Blessing of Pope Pius XII, I knew for the first time the true meaning of the word 'city' as the centre, not only of a national culture, but of a world religion. I soon realised that the crowd-filled piazza under the roof of a brilliant blue Roman sky was not quite the centre of the world.

It was only when I entered St Peter's that I realised it was the Bernini High Altar. I understood then the full implications of the word 'altar' as the 'Sanctum Sanctorum' of the city. Tens of thousands of people from every country imaginable had gathered to pray in one language before the steps of an altar under a vast dome in the presence of the Pope himself. It was my first experience of the 'total art work' involving religious ritual and sculpture on a gigantic scale. It was the *Gesamtkunstwerk* created for the best possible reason. Of course, by 1950, I must have benefited from three years' experience of Edinburgh transformed by art for three weeks annually into a world capital of culture, through the Edinburgh Festival, established against all the odds in 1947. I knew therefore that the experience of art was inextricably linked to the experience of a city which was itself an artwork. Through the combined experience of the Holy Year 1950 and the Edinburgh Festival, the word 'city' became identified in my mind with the words 'art' and 'prayer'. I knew that, when these three words could be linked significantly, I could imagine that God was in His Heaven and that the concept of the Communion of Saints was being well

defended by those inhabitants of the world who defined themselves as city dwellers.

However, since 1950, the concept of the city as I had imagined it in my youth is almost impossible to defend after the full impact of four decades of ever increasing materialism spreading through Europe, emanating from the basically protestant culture of the New World defined by the United States of America. Sadly, it is the image of New York, not Rome, which the politician, the banker and the industrialist have when they conceive of the city's shape in the last part of the 20th century. Nowhere is this more clearly seen that in London where the towers and skyscrapers of New York's Wall Street have been built anew to deny the very existence of London's equivalent of St Peter's, the great masterwork of Christopher Wren, St Paul's Cathedral. The so-called 'great' American cities are all built on a fundamental heresy that the city dweller's main function is to worship at the high altar of Mammon to the point where the life of the spirit personified by the cathedral is well-nigh obliterated. When I think of the much-vaunted new American cities and their so-called centres, in Houston and Dallas, and their British counterparts of Birmingham and Manchester, I cannot think that the word 'city' should be identified with the word 'civilised' or with the age old concept which held sway all over Europe, even into the immediate post-war period, that a city's credentials lay in the dominating presence of its cathedral.

More and more, we are faced with the inescapable fact that the arts can be supported only through their capacity to be identified with monetarist value systems despite the fact that the evidence of European history

makes it clear that art can only flourish when the artist is in dialogue with the banker and the merchant through an intermediary in the form of the bishop, praying at his cathedral's high altar. The Medici alone could not have produced the glories of the Renaissance in direct dialogue with the artists they admired because governing the Medici thoughts and attitudes and their favourite artists, despite all their world power and pride and sinfulness, was the basic universal belief that mankind's destiny and all human activities were governed by spiritual dimensions. Evidence for this can be found even to this day in the city centre of Florence, Venice and Sienna where the marketplace and the seat of civic government were built within the domain of the cathedral.

There is only one comparable city I can think of in Britain and that is Edinburgh because it still possesses the vestiges of a cultural and political capital and because its architectural shape and history is dominated by a cathedral precinct which is bordered at its highest point by an abbey and a palace. The cathedral is dedicated, not to a Scottish saint, but to St Giles, better known in France as one of that band of Irish missionaries who spread the Celtic culture from the Atlantic shores of Europe deep into the Mediterranean. St Giles Cathedral is positioned, literally, at a point known as the Heart of Midlothian, defining the centre, not only of Edinburgh, but the whole surrounding area. Its cathedral tower is in the shape of the crown of Charlemagne, an architectural form peculiar to Scotland and evidence of Scotland's close links with the medieval Roman Catholic world all over the European continent. The St Giles high altar is located halfway between two altars marking other altars. One is in the Abbey of

Holyrood and the other is in the Chapel of Queen
Margaret, the one and only Scottish monarch who
attained sainthood. It is the oldest building within the
Edinburgh Castle walls and rightly built upon the
highest point of the Castle Hill. All three altars are
linked by what is called the Royal Mile defining the
medieval High Street. The tiny Romanesque stained
glass window behind the altar of St Margaret will
direct your gaze towards the lowest point on the Royal
Mile where the street ends at the altar of King David II.
The altar exists within the impressive ruins of Holyrood
Abbey adjoining the Palace of Holyrood House for the
simple reason that Divine intervention caused the life
of King David, the grandson of Queen Margaret, to be
saved when alone and imperilled in the depths of what
was then a royal forest, he found himself face to face
with a legendary white stag. The stag's life was spared
and so too was the King's when he found himself with
the stag at bay unexpectedly surrounded by a pack of
wolves. At the moment of truth, there appeared mira-
culously between the antlers of the stag a blinding
cruciform light which struck terror into the wolves.

The miracle took place half a mile from where the
12th century city walls had ended at the Netherbow
Gate. It is nowadays marked by brass plates embedded
in the Royal Mile's cobbles. Appropriately this point is
known even today as 'World's End' for at that point
the city and the life of civilised man ended and the
untamed, ungovernable, unknown spaces of the wilder-
ness began in the form of the royal forest. The extension
of the city in succeeding centuries had to take into
account that point in the forest where the life of the
King had been spared, and so it is that the medieval

city of Edinburgh and its Royal Mile owes its eventual shape not to the machinations of town-planners but to an act of Divine intervention. This story should be told to anyone wishing to play the role of an Edinburgh Festival-goer, particularly those concerned with what is called the Edinburgh Festival Fringe, because the Fringe was born within the structure of that Royal Mile, in all manner of temporary converted premises in church, school and masonic temple halls located in the alley-ways. One of these halls was converted into Edinburgh's Traverse Theatre. The five-year story of how this came to be defines the beginnings of my work as an art gallery and theatre director.

The language of art under the aegis of the Edinburgh Festival transformed Edinburgh's Old Town, giving the streets and buildings new life and meaning. Edinburgh was chosen as the world capital for art because of the beauty and sacred nature of its historic Old Town fabric.

There is a lesson for all modern architects in this inescapable truth and it should provide inspiration to those who would wish to build the cities of the 21st century, to accommodate the dimension which art provides in the form of international festivals.

Schools of architecture would have to consider tea-ching their students how to cope with what nowadays is called 'performance art'. In the hands of master artists such as Joseph Beuys, Tadeusz Kantor, Alistair MacLennan and Paul Neagu, this form of visual arts expression can work most effectively in helping to focus attention upon the ills which nowadays beset most cities as well as upon the points of high, life-enhancing energy to be found in unexpected aspects and areas of the city's fabric. Most 'performance art' work relies

heavily upon the physical presence of the artist in confrontation with an audience. The performance artist thus focuses attention upon the sacred nature of the human presence as the measure of all man-made things, from furniture, architecture to all manner of ornaments and implements, utensils, machinery, vehicles, clothing, jewellery and regalia. The everyday, as well as ritual, uses of all such things are the very stuff and substance of the performance art work, particularly when they are related directly to the elemental dimensions of time and space.

'Performance art' is essentially a form of drawing through what Gaston Bachelard, the French phenomenologist called, *La Poetique de l'Espace*. Performance art reveals 20th century man's need for ritual. The artist's work through performance art can be linked to that of the ritualist, alchemist, priest and master of ceremonies and guide and explorer, of all the secret places normally hidden from view, which we need to know to truly inhabit a living space, both interior and exterior. The artist reveals how we should be able to love these spaces if we are obliged to share them with others. This includes in particular those spaces which we have so misunderstood that they have become associated with violence, decay, illness both mental and physical, and which are totally uninhabitable. These are all too clearly associated with the modern city centre with its streets, pavements, street furniture, public waiting rooms, stairways, parks, footpaths, corridors, lifts and underpasses. Joseph Beuys pinpointed the problem with his masterwork *Tallow*, a gigantic mould in life-enhancing fat of an entirely negative civic space, that of the ubiquitous motorway underpass. It

was he who, more than most artists, made performance art an acceptable term of reference defining that area of the contemporary visual arts which lies somewhere between painting, sculpture and drawing and all the performing arts regarded as theatre, opera, dance and music.

Unfortunately, I have always found such terms of reference somewhat misleading and therefore unacceptable. It cannot accurately describe what is undoubtedly a manifestation of the arts of our time and a phenomenon of post-war activities into misleading and virtually useless categories.

In British art schools, painting and sculpture tend to be considered irrevocably separate activities. In the United States, Canada, Australia and New Zealand and certainly in Eastern Europe from the experience of my own travels lecturing in over 150 art schools, galleries and universities, I know that performance art has begun to be regarded as a manifestation of drawing, painting and sculpture. If I have to find *le mot juste*, I would say that all aspects of the visual arts aspire to the condition of drawing. Perhaps the Italian word *disesnare* best describes it because from it is derived the English word 'design' which I have always thought is misleading. To say that a teapot is well designed is not at all satisfying or acceptable to me. I prefer to say that a teapot is 'well drawn' three-dimensionally. The question arises, can the teaching of design be truly effective if it does not take into account performance art.

Perhaps performance art could be better defined as 'ritual drawing'. Certainly that is how I would describe Joseph Beuys' first-ever performance in Britain. It added a mind-boggling new dimension to the Edinburgh

Festival's idea of what art could be. It was called *Celtic (Kinloch Rannoch) The Scottish Symphony*. It was about the music which the Danish performance artist/composer Henning Christiansen created in collaboration with Joseph Beuys and the sound of the Gaelic language and the language of animals intoned as a form of prayer. It was a requiem celebrating the lives of all the artists who Joseph Beuys admired throughout the ages.

He was partly inspired to make this work when he saw the preparations for another concert of music presented by the Demarco Gallery at the same time, also as part of the 1970 Edinburgh Festival. This was the result of a collaboration between Harrison Birtwistle, Alan Hacker and Keith Critchlow, called *Sound in Space*. It was certainly much more than a concert in the acceptable sense because it aspired to the Beuysian view that sound was an essential ingredient to those artists attempting to redefine the nature of drawing.

In my mind's eye, there is a list of names alphabetically arranged of the artists presented by the Demarco Gallery who chose to represent themselves with performance art as a part of the Gallery's 'Edinburgh Arts' programme of activities over the past 21 years. The nationality of each artist and the year in which each artist first made a performance for the Demarco Gallery are also listed. Such a list helps me to say how 'Edinburgh Arts' as an international experimental summer school, beginning and ending in Edinburgh, emphasised the role of the 'artist as explorer', prepared to be involved in the physical reality of Europe, its geography, history and pre-history and cultural origins through direct dialogue with artists, musicians and writers in studios, places of education, churches, hospitals, prisons, galleries, museums

and other places where artistic life had developed and endured. 'Edinburgh Arts' journeys over land and sea enabled the Demarco Gallery to present performance art works all the way from the Hebrides to the Cyclades and from the Maltese temple of Ħaġar Qim to its Orcadian counterpart of the Ring of Brodgar, to prehistoric sites associated with religious ritual activities. It was also about specific journeys from Scotland, through England to Poland, Holland, France and Italy. 'Edinburgh Arts' is the Demarco Gallery's acknowledgement of all places of experimental art education such as Black Mountain College, the Bauhaus and Dartington and was presented in association with Edinburgh University's Schools of Scottish and Extra-Mural Studies, so that students of art could benefit from university credit systems.

'Edinburgh Arts' as an experimental form of art education became identified with Joseph Beuys' 'Free International University' when, as part of 'Edinburgh Arts' circumnavigation in 1980 of the British Isles on the sailing ship *Marques* and representatives of the Free International University as part of the 1980 Demarco Gallery's Edinburgh Festival exhibition programme, Joseph Beuys presented a three-day 'Action'.

The following is a list of 66 artists which forms the nucleus of a larger list of names which I have to keep in mind when considering the story of Performance.

Marina Abramović, Akademia Ruchu, Woody van Amen, Anselmo Anselmi, Betty Beaumont, Bill Beech, Joseph Beuys, Remo Bianco, Barbara Bouska, Paul Bradley and Babel, Paolo Cardazzo, Steve Carrick, Giuseppe Chiari, Henning Christiansen, John Cousins, Ivor Davies, Michael Docherty, Friedhelm Döhl,

Andrew Drummond, Valie Export, Lily Eng, Robert Filliou, John Faichney, From Scratch, Rose Finn-Kelcey, Rose Garrard, Anne Gauldin, Cheri Gaulke, Doug Hales, Anthony Howell and The Ting Theatre of Mistakes, David Helder, Phil Hitchcock, Tom Hudson, Lyndal Jones, Mauricio Kagel, Zofia Kalińska and Akne Theatre, Tadeusz Kantor and Cricot 2 Theatre, Tina Keane, Barbara Koslowska, Christine Koenigs, Ferdinand Kriwet, Alex Landrum, Richard Layzell, Tom Marioni, Tony Morgan, Alastair MacLennan, Bryan MacDonald, Zbigniew Makarewicz, Michael Meyers, Paul Neagu, Paolo Patelli, Neša Paripović, Zoran Popović, Sally Potter, Nigel Rolfe, Guido Sartorelli, Bogusław Schaeffer, Anne Seagrave, Daniel Spoerri, Peggy Stuffi, Sister Scipion Theatre, Raša Todosijević, Günther Uecker, Zbigniew Warpechowski, Steven Whiteacre, George Wyllie.

Contemplating this list, it is evident that the most famous name is that of Joseph Beuys. As it is almost two years since his untimely death, I must consider who on that list had a dialogue with Joseph Beuys which directly concerned art in relation to the Demarco Gallery. The list represents almost 150 artists as it includes all those involved in such companies as Akademia Ruchu, Sister Scipion Theatre, From Scratch, Cricot 2 Theatre, Akne Theatre, Babel and the Ting Theatre of Mistakes.

With the subject of the artist and the city, the name of Paul Neagu comes immediately to mind, because in his first meeting with Joseph Beuys under the aegis of 'Edinburgh Arts' in 1974, he asked Joseph Beuys to consider the nature of the head as the most important part of the human body, and because of its function and structure, it could be likened to the position and shape

of the capital city of any country in relation to the physical landscape of the country it governs.

In the human head and the capital city resides the seat of government. The cathedra contained in the human mind functions to relate all natural things Heavenwards. However, the mind contained within the head is totally dependent upon the body and its limbs which are organically earth-bound so that the mind should not forget its earthly origins.

Paul Neagu's 1974 'Action' *Going Tornado* clarified the need for balance between mind and matter, between the seat or cathedra of government and all points of contact with the earth, through the force of gravity and all objects extending the body's presence in the form of clothing, utensils and instruments of measurement, of time and space, as well as nourishment in the form of food. The tornado unleashes power, both negative and positive, a symbol of nature's regenerative power.

Paul Neagu places the human presence firmly within the centre of the tornado, not outside it. All his artworks since continue to give positive images of man at one with nature. My words could not be better symbolised than in a drawing which Paul Neagu entitled *Fish Over Gate*. In it, the male symbol of the city built upon a magic mountain defined by the forms of castle and cathedral juxtaposed is seen to produce the reality of 20th century flying machines. The flight path of the ill-fated *Challenger* shuttle is symbolic of Icarus for our time. He speaks eloquently thus of the city in relation to the female energy of the earth and sea and the life-enhancing forces which flow when cityscape and landscape are totally interdependent.

Thus Paul Neagu personifies that artist who, whether

he likes it or not, is prepared to continue working using performance art or drawing or whatever means of appropriate expression which can be linked to those heroic figures who have set the ground rules of artistic endeavour. They inspire terror as well as inspiration. Among them you will find Leonardo da Vinci, Michelangelo, Gian Lorenzo Bernini, Vladimir Tatlin, Kazimir Malevich, Yves Klein, Mark Rothko and Joseph Beuys. All of them are distinguished by their preparedness to work in and around the cathedra or throne of government as the centre of the city built to express mankind's presence upon the surface of the earth as proof of a Divine order in which art is an expression of ritual praise and thanksgiving.

I believe this is possible in my own lifetime because Edinburgh proved itself to be such a city when it was chosen to be the place of pilgrimage for all the world's artists wishing to celebrate the ending of the Second World War and the promise of peace.

Richard Demarco, for *Performance* Magazine, 1987

Performance Magazine

In November 1987, I was invited to contribute an essay to the special 50th anniversary issue of *Performance* magazine. I was interested to do so because this issue entitled 'The City and its Double' contained an interview with JG Ballard. It also contained an essay on the art of John Cage and Merce Cunningham, two artists I associated with Black Mountain College, as wells as an essay on Poland's 'Akademia Ruchu', a group of artists renowned for making performance art for city streets.

Performance magazine linked 'performance art' with modern art, theatre, music, video, dance and spectacle.

It therefore dealt with the changing nature of the international art world in the 1980s. It should be noted that this particular issue came into being a year after the death of Joseph Beuys.

My essay made me reflect on the reasons why I felt it was necessary for Joseph Beuys to be associated with Scotland and Edinburgh in particular as the one European city blessed with a world-renowned international festival of all the arts. Edinburgh had a distinct profile. It was worthy to be defined as a Northern European equivalent of Florence. For this reason, Edinburgh and Florence are designated as twin cities. Florence is a city manifesting the true spirit of the Italian Renaissance. Edinburgh embodies in its Georgian New Town the spirit of the Scottish Enlightenment. Florence is a true cathedral city with its majestic Duomo; Edinburgh has not one but three cathedrals, one Roman Catholic, one Episcopalian and one Presbyterian, though medieval in origin.

At one most moving section of *Celtic (Kinloch Rannoch)*

The Scottish Symphony, Beuys stood motionless over what he defined as 'The Tomb of the Unknown Artist', bestowing upon this four-hour-long performance the aura of a Christian requiem. This was a perfect example of the performance art of Joseph Beuys.

In 1987, I was most aware of the fact that Joseph Beuys had made it clear that two of his contributions to the seminal 1970 Edinburgh International Festival exhibition *Strategy: Get Arts* emphasised his unique capacity to execute his art in what he preferred to define as 'Actions' rather than 'Performance'.

Arena was installed in one of Edinburgh College of Art's life painting studios, next door to the studio where he made and enacted what he entitled *Celtic (Kinloch Rannoch) The Scottish Symphony*. He made this in collaboration with his close friend and fellow artist, Henning Christiansen, who was considered to be the Danish musician and composer making *avant-garde* music equivalent to that of the American *avant-gardiste*, John Cage.

Under the aegis of the Demarco Gallery's experimental Summer School 'Edinburgh Arts' inspired by Black Mountain College as the American version of The Bauhaus, Joseph Beuys made a number of 'Actions' in Edinburgh and in the Celtic landscape of Scotland.

I associate most of these with non-gallery locations. For example, he made *New Beginnings are in the Offing* in the fabric of Edinburgh's medieval Poorhouse at Forrest Hill, situated in the historic graveyard of Greyfriars Kirk. Also with the studio space of Edinburgh College of Art, Melville College and the Groves-Raines architectural studio in the Royal Mile, as well as in the landscape of what I define as the Road to Meikle

Seggie, incorporating Rannoch Moor and the Argyll-shire shorelines of Loch Awe.

What is 'The Double of the City?' It is for me how key sites in the city were transformed by the art of Joseph Beuys, working in partnership with myself, who was concerned for these vulnerable sites, knowing they were in need of being immortalised by the genius of Joseph Beuys.

Richard Demarco, 2016

Ryszard Stanisławski on *Polentransport*

In 1989, I was invited by the Hungarian Ministry of Culture to visit Budapest. I was fortunate that this visit coincided with the *Polentransport* exhibition. This consisted of a part of the collection of nearly 1,000 art works which Joseph Beuys gifted to the Muzeum Sztuki in Łódź. It was in fact a gift to the people of Poland during the period when Poland was under martial law and fighting for its very existence.

Joseph Beuys and Ryszard Stanisławski, the Director of the Muzeum Sztuki, were both involved in the Demarco Gallery's 'Edinburgh Arts' programmes.

Ryszard Stanisławski was one of the few art historians who fully understood the important and unique role which Beuys chose to define through his art. He wished to express his respect for Poland's artists and for the ways in which Poland managed to recover from the pain and suffering inflicted on Polish people. To help heal the wounds inflicted by both Hitler's Germany and Stalin's Russia, he made this most generous gift as an act of reconciliation and in the firm belief that the language of art is a healing balm.

The Budapest exhibition catalogue has a preface written by Ryszard Stanisławski. I do believe it is a true homage to Joseph Beuys, marking him apart from the limitations of the art world, suffering from the impact of rampant economic forces which reduce art works to a commodity. Ryszard Stanisławski has in this short essay defined the nature of the work identified with collaborations with Joseph Beuys over the period of 1970 to 1986. For this reason, I wish to quote the words of Ryszard Stanisławski in full. They explain why it

was important to Joseph Beuys, personifying German art, should meet Tadeusz Kantor, personifying Polish culture, under the aegis of 'Edinburgh Arts' in 1973.

PREFACE TO THE CATALOGUE OF BEUYS' EXHIBITION IN BUDAPEST

A major part of the collection that was given by Joseph Beuys to the Museum of Arts in Łódź in 1981, is now on display in Budapest.

Beuys' original, agitating and permanently inspiring figure revalued the art of the 20th century in more ways. I am convinced that the Beuysien 'provocation's manifestations in practice were not only those art actions known from descriptions – in the streets, in the School of Art in Düsseldorf, in the Documenta of Kassel, in New York and those interventions, statements, environments and didactic lectures – but first of all that responsibility he felt for the permanent existence of culture and for phenomena – sometimes contradictory phenomena – of culture. I think that was the reason he bestowed most of his oeuvre on our museum.

Beuys was not motivated by prestige or success-mongering – he did not need those. As I recollect from our meetings he truly believed that to donate his collection to the Museum of Łódź – ie an East European museum – would be the evidence of the unity and indivisibility of European culture.

The fact that the modern art collection of this museum had been created disinterestedly by the solidary will of European *avant-garde* artists in the '20s and '30s, such that it became the document of an international mission, was important to him.

The collection which consists of almost 1,000 works – drawings, lithographies, aquarelles, multiplicated spatial objects, sealed and signed photos and writings

documenting the actions – reflected and summarised even in his life this mutable, dynamic creator who devoted himself to art completely. In the elements of this collection one can feel the surge of ideas, the repetition of typical motives, his creative public action and in the watchword-like Beuysian economic and political manifestations. Moreover, these found a quite characteristic expression in his manifestoes to the artists of Łódź, calling for the liberation of social and political relationships from brutality, aggression, routine, egoism. According to Beuys' art, the concord of people in the name of culture and the artistic activity of the average man should play a more inspiring role in this process.

Joseph Beuys' figure is part of history. His message is deeper and more universal than that of other contemporary artists whose criticism and creativity moved in a much more limited circle. Having made his personal presence felt several times, he had a big influence on the '70s and the first part of the '80s. He made it clear for every sensitive intellectual community of the civilised world that fear and pain, intuition and obsession, the return of ancient traditions and the dominance and horror of individual memories, the everyday feelings of embarrassment or friendship towards all living creatures, mean common root for man's problems and experience.

All of these can be gathered from those works Beuys left one day in Łódź, when he appeared with his family and a huge box with the inscription 'POLENTRANSPORT-81'. The box was full of papers and embodied a feeling of unity.

We have been looking forward to seeing him very much.

Ryszard Stanisławski
Director of Muzeum Sztuki
In Łódź, 1993

Thoughts on the ending of 1993 – and the significance of *Strategy: Get Arts*

The roles of Gallery Director and University Professor are not normally considered interchangeable or for that matter interconnected, unless, of course, the concept of the Gallery has within its function and purpose, the aims and objectives of university education.

Looking back to 1947 and the impact the very first Edinburgh Festival had upon my mind and soul, I realise it confirmed me in my vocation not only to study and practise and present art, but to teach it, and thus I managed to transform the Demarco Gallery, in collaboration with Edinburgh University under the aegis of 'Edinburgh Arts' (an Edinburgh Festival Summer School) into a 'university' environment in which, for example, Joseph Beuys, Tadeusz Kantor, Buckminster Fuller, Paul Neagu, Lord Ritchie Calder, Hugh Macdiarmid, Ronald Penrose and George Melly could teach an international body of students representing both art schools and universities. This experiment in education through all the arts came into being as a direct response to the Demarco Gallery's 1970 Edinburgh Festival exhibition entitled with the provocative palindrome *Strategy: Get Arts*. This exhibition was presented at Edinburgh College of Art as conclusive proof that the full-blooded *avant gardism* expressed by Düsseldorf-based artists could transform Edinburgh College of Art into an art gallery, linked to a three-week long, multi-faceted masterclasses of emphasising the interlocking and complementary natures of art school and university system of education.

The Edinburgh Festival was created to celebrate the

ending of the Second World War. It transformed
Edinburgh's image as Scotland's capital city to the
status of world capital of all the arts for an annual
period of three weeks in every year from 1947 until the
present. It was born in the immediate post-war period
which also supported the concept of the Arts Council
to assure funding for the Arts in Britain. It was an age
of belief in the Arts, of clear-thinking and an age of
new beginnings as an alternative to the madness of the
war-time years.

Almost a half-century later the Arts are embattled
and the very life of the Arts Council endangered and
Lord Palumbo, the Council's Chairman, is obliged to
write in the Arts Council's defence against what he calls
'an accountability obsessed Government'. His belief in
the efficacy of the Arts to defend the most basic tenets
of a civilized state inspire me to put into writing my
thoughts as 1993 comes to an end and the new year
dawns. The last two sentences of Lord Palumbo's
defence of the Arts Council constitute a rallying call:
'The quality of the Arts is the surest indication of the
health of any society that claims to be civilized. That is
what we fought for 50 years ago; the fight is still on.'

I believe this fight must result in victory for all those
who are committed to the Arts in Britain only when
whatever is considered to be Art is considered to be part
of the process of education. Indeed, Art and Education
are but two sides of the same coin and when the
currency of that coin is properly valued by a civilised
state, it will be seen to defend the very environment in
which the nations of the earth struggle to survive – and
solve the basic problems resetting western society,
causing violence and despair to despoil the environment

of our cities – and cause the very physical presence of human beings to endanger the proper workings of nature.

That is why I find it entirely natural that after 30 years involved in directing programmes of the performing and visual arts, I have been able to accept the Professorship given to me one year ago by Kingston University, and why I consider my work directing the Traverse Gallery, the Demarco Gallery, the Edinburgh Festival 'Edinburgh Arts' Summer Schools and expeditions as but a preparation for my professorial duties.

This professorial role enables me to demonstrate more clearly than ever before that the natural patron of all the Arts should be the University. Kingston is well able to provide such patronage, with its flourishing Schools of Fine Art, Architecture and Music and its preparedness, through its Faculty of Education, to support the performing arts, and in so doing to link the Arts to the Sciences and to Law and Business Studies.

1993 has been a year of extraordinary change and challenge. I have been privileged and inspired by my experiences of such Summer Arts Festivals in Poland as those of Sanok and Radom. They revealed how outstanding international professional practitioners of theatre and Polish schoolchildren can work together to create the kind of energy and commitment which revitalises education through art.

My November discovery of Latvia and Estonia was made possible through the collaboration of Gabriella Cardazzo who since the 1970s has shown an instinct to be at the frontiers of the New Europe. The National Art Academics of both Latvia and Estonia are now prepared to engage in cultural dialogues linking them with Kingston and Edinburgh.

Under the patronage of Bryan Montgomery, I was able to present an exhibition at the Budapest Art Fair and to lead an expedition to the Budapest Spring Festival, presenting the paintings of Giancarlo Venuto at the National Art Academy and Chamber Theatre productions at the RS9 Theatre of Katalin Laban. By journeys from Budapest to Vienna the cultural heritage linking these could be considered with particular focus upon the interface between experimental dance and visual arts, as defined in the work of Sebastian Prantl.

The Venice Biennale was memorable for the international conference staged by the Kingston Demarco European Art Foundation in the Villa Foscarini Rossi in relation to an exhibition of Ainslie Yule's large-scale sculpture *Three Score Years and Ten*, and the exhibition of six Hungarian artists selected by Lorand Hegyi. Ellen Meyer, President of Atlanta College of Art, was one of the conference speakers who reminded the delegates of the challenge of the Atlanta Olympics and the role she must play within the Olympic cultural programme. Three weeks before the Biennale opened, Ellen Meyer had helped strengthen Kingston University's links with the United States by the warm welcome she gave to in Atlanta to Dr Robert Godfrey, Pro-Vice Chancellor of Kingston University, and to myself at Atlanta College of Art in relation to the College Annual Degree Awarding Ceremony, at which I was honoured to receive an Honorary Doctorate of Fine Art.

The Edinburgh Festival enabled me to bring together theatre from Bosnia, Croatia and Serbia and to present the very first exhibition of Bosnian art to emerge from besieged Sarajevo with the indefatigable support of Miro Purivatra and the artists of Sarajevo's Obala Gallery.

Theatre productions from Hungary, Poland, Israel, England and Scotland, as well as an international exhibition of site-specific art works, helped transform St Mary's School into the ideal new home of the Demarco European Art Foundation, and provide a place for Kingston University Fine Art students to work and present their sculptural response to the Gallery's Archive. A highlight was Ela Bojanowska's workshops with students from Cheltenham Ladies' College, Radley College and Shrewsbury School.

In autumn, John Calder's two-day seminar at Kingston fully explored the history of ideas as expressed by writers and artists during the period when modem art philosophies developed. Many of the writers he spoke about with conviction and passion were those he himself had published, including Samuel Beckett, Alain Robbe-Gaille and Marguerite Duras. The spirit of modernism which this seminar explored was dramatically extended in Yvette Bozsik's masterclass at Kingston where over 200 Kingston students were enthralled by Yvette's skill in bringing the excitement of her award-winning Edinburgh Festival production *Soiree* to the University's De Lissa Theatre. In February she will return with a Kingston Fellowship.

The whole extraordinary year seemed to accelerate in pace and intensity of ideas generated by the conferences and exhibitions which celebrated the lives of three 20th century polymaths: Joseph Beuys, Sir Herbert Read and D'Arcy Wentworth Thompson. Through their achievements Art, Science and Philosophy are intertwined.

There was the Joseph Beuys conference at the Tate Gallery in Liverpool. *Beuys Then and Now* was the title I had suggested as the most appropriate due to the

fact that his life force seems to influence the art world nowadays even more than during his lifetime. It was enlightening to listen to old friends such as Rudi Fuchs, Johannes Cladders and Friedhelm Menneke speak with deep insight about their historic work with Beuys.

After being invited to speak at the reconstituted Leeds Art Club by Benedict Read, the son of Sir Herbert Read, it seemed absolutely necessary to see the great exhibition presented by Leeds Art Gallery celebrating the 100th anniversary of Herbert Read's birth. Ben Read's editorship of the exhibition catalogue is a timely reminder of his father's unique achievements in persuading a reluctant British art world to engage 'in the spirit of modernism which flowed from Europe between the two Great Wars'.

The Edinburgh conference at the Royal Botanic Garden on 'Growth and Form' was inspired by the life and work of D'Arcy Thompson, the St Andrew's University classical scholar and zoologist. To quote Professor Martin Kemp's introduction to the Conference 'Thompson's insights stand in the great tradition of the seekers for order in nature, seekers who include philosophers, literary figures, artists and musicians from classical antiquity to the present.' These conferences could well have been taken into account by the delegates and speakers participating in the December conference presented by Southampton University on the subject of the 'European Perspectives on Today's Fine Art Education'.

My two visits to Leeds enabled me to catch up with the work of the indomitable arts patron, Sir Ernest Hall, who has literally rebuilt the physical fabric of his beloved city of Halifax by his commitment to the visual and performing arts, centred on Dean Clough, which is

now linked as an arts centre to a project he inspired called Eureka which gives a new meaning to the concept of a museum for children, celebrating every imaginable aspect of science and the world of modem technology. It would seem inevitable that the success of Eureka could lead to the development of a similar concept of a children's museum celebrating the way in which art is made and expressed.

My year at Kingston ended on the optimistic note personified in the work of Anne Grant as Director of the office of Green Cross in London. Her meeting with Dr Robert Smith, Vice-Chancellor of Kingston University, led to her inviting Professor Ronald Coleman, Chairman of Kingston University's Board of Governors, to the meeting at the Dorchester Hotel at which Mikhail Gorbachev, as World President of Green Cross, spoke about his commitment to the defence of the world's environment to a small group of scientists, environmentalists and Green Cross officials, who as a result of his speech, are prepared to establish a British office of Green Cross to work in collaboration with those offices already established in Switzerland and Holland. As a member of the Green Cross Executive Committee I am myself inspired by the thought that the location of such an office will be housed at Kingston University.

Richard Demarco, 1993

The Genesis and Legacy of *Strategy: Get Arts*

I had been introduced to modem art through my child-hood love of the Art Deco buildings of John Houston, the Ayrshire architect, all commissioned for Largs in its heyday as a 1930s holiday resort on the Clyde. I was in Largs in 1940 and 1941 because my father was manager of The Moorings, the most famous Art Deco landmark in Largs, commissioned by the Castelvecchi family. The others were Nardini's Cafe and the Viking Cinema, the perfect environment for me to experience Alexander Korda's film version of HG Wells' novel *Things to Come*. Most of the action took place in the interior of a space-craft designed by Mohly Nagy, the very personification of the Bauhaus artist.

The post-war years brought an end to the Art Deco movement, but the Festival of Britain gave me an insight into the future as seen through the eyes of modem British artists. The Edinburgh Festival committed itself in its early years to the art of Rembrandt, Degas, Renoir, Vuillard and Bonnard, and it was not until 1954 that it committed itself to Cezanne, the father of modernism in painting and, along with it, more importantly for me, through the genius of Richard Buckle, the world of Diaghilev. This was revealed in the Edinburgh College of Art, proving it to be the most inspiring gallery space in Edinburgh. With it came the art of Picasso, Matisse, Derain, Braque and Cocteau related to Les Ballets Russes and the music of Stravinsky. In 1961, he brought the sculpture of Epstein to the Festival and in so doing transformed the Waverley Market into Edinburgh's first gallery of modem art. It was sadly short-lived.

Richard Buckle became my first patron and introduced me to the modem dance world of Martha Graham and the spirit of the Bauhaus expressed through its American reincarnation in the bucolic world of Black Mountain College.

It was this exhibition which sowed the seeds in my imagination to consider The Edinburgh College of Art as the ideal location for the Demarco Gallery's Official Edinburgh Festival Exhibition of Contemporary Art from Canada in 1968.

Strategy: Get Arts followed in 1970. It fulfilled the aims and ideals of the Demarco Gallery's founders: Andrew Elliott, John Martin, Jimmy Walker and myself as Artistic Director, to help internationalise the Scottish art world by linking Scotland to a Europe which was showing, in West Germany, all the signs of hopeful regeneration.

They were deeply involved, as I was, in the founding of the Traverse Theatre, and, in so doing, had become friends with Jim Haynes and John Calder who met through the Paperback Bookshop which Jim Haynes had opened in Edinburgh in 1959. Through their friendship and their commitment to the history of ideas expressed through literature, there came into being The Writers' Conference in 1962 and its successor The Dramatists' Conference in 1963. John Calder was the publisher of Samuel Beckett and supporter of French 'Nouvelle Vague' writers such as Francoise Sagan and Alain Robbe-Grillet. His friendship with Sonia Orwell was crucial to the success of these conferences because of her own friendships amongst the leading *avant-garde* writers of the '50s and '60s.

I firmly believe that true and enduring art and art initiatives originate in the meetings of friends and their

shared values and ideals. Without the friendship of Rudolf Byng, Tyrone Guthrie and Lady Rosebery, the Edinburgh Festival would not have come into being, and without the Festival's international arena, there would have been no Paperback, no Traverse and no Demarco Gallery.

The first Edinburgh Festival took place in 1947 as a celebration of the coming of peace to a Europe still war-torn and facing up to the beginnings of a Cold War which would imprison 200 million Europeans behind the Berlin Wall.

The Dramatists' Conference had tested the Edinburgh Festival to the breaking point because it had ended with a 'happening', an expression of the most advanced concept of international *avant-gardism*, born out of the revolutionary spirit of the Dadaists.

The Edinburgh 'happening' was the handiwork of Allan Kaprow, the renowned American originator of the 'happening' as an art work, and the Scottish artist, Mark Boyle. It shocked the Edinburgh Festival and caused the resignation of its Director, Lord Harewood.

This helped inspire me to plan an exhibition progr-amme for the years 1963 to 1964 at the Traverse Theatre Art Gallery for such artists as Mark Boyle, Jasper Johns, Abraham Rattner (the friend of Henry Miller who had attended the Writers' Conference) and Cecil King, the Irish artist who, with his friend Michael Scott, was in the process of planning an international exhibition in Dublin to be entitled ROSC.

The first ROSC was presented in the gigantic space provided for the Royal Dublin Horse Show. It presented the world's leading artists chosen by a jury which included James Johnson Sweeney and Willem Sandberg, two of the great defenders of the *avant-garde*. This took

place in 1967, one year after the Demarco Gallery's inaugural exhibition, and in the same year that my good friends, Roland Penrose and David Baxendall helped me present Scotland's answer to *The John Moores* exhibition in the form of the *Edinburgh Open Hundred*, an open painting competition which attracted 2,500 British artists.

At the ROSC exhibition, I met John Latham, the English artist who was represented by his burnt book sculptures, and also Gunther Uecker, who personified the work of Group Zero, the group of German artists which exemplified the spirit of the New Realists initiated by Gunther Decker's brother-in-law, Yves Klein and Pierre Restany, the French art critic.

It was this spirit of New Realism which predominated the first major exhibition of the Demarco Gallery, presented in collaboration with The Galleria Nazionale D'Arte Moderna in Rome, the Ulster Museum and the Oxford Museum of Modem Art. This also took place in 1967 and helped the Demarco Gallery prepare itself for its collaborations in 1968 with the unions of artists in Poland and Romania. In my travels to these East European countries, I found ample evidence that the Dadaists were being taken into serious consideration along with the legacy of the Russian and Polish Constructivist artists.

I met new friends in Poland, Rsyzard Stanisławski, Director of the Museum Sztuki in Łódź and Wieslaw Borowski, the Director of The Gallery Foksal in Warsaw. In 1968, I also had my first experience of the Venice Biennale, representing the winner of the Biennale's Sculpture prize, Edgar Negret, the Columbian artist, and in that year at the *Documenta* exhibition in Kassel,

I had my first experience of Joseph Beuys as he installed one of his masterworks.

I recognised him from the little book published in June 1965 by Rolf Jading, the director of the Galerie Pamass in Wuppertal as documentation of the 24-hour 'happening' entitled 24 *Stunden*. This had brought together Joseph Beuys and one of his students, Ute Klophaus and the Fluxus artists: Bason Broch, Nam June Paik, Charlotte Moorman, Wolf Vostell, Thomas Schmidt and Eckhart Rahn.

Looking back over four decades to 1970 when Brigitte Lohmeyer invited me to visit West Germany almost immediately after my first tour of the United States, I wonder how I knew that I should not plan an exhibition of world-famous New York artists for the Festival, and instead, favour artists virtually unknown in Britain. The creative spirit that I encountered in Düsseldorf was undoubtedly preferable to that which I found in New York. This was encapsulated in the exhibition *Strategy: Get Arts*.

The spirit of *Strategy: Get Arts* lives on 35 years later. It marked a focal point in the Demarco Skateraw Project exhibition which the Demarco European Art Foundation presented, beginning in the final week of last year's Edinburgh Festival.

The Skateraw exhibition was complementary to three Festival exhibitions which also evoked the spirit of *Strategy: Get Arts*. They defined a tri-partite programme inspired by the life and work of Blinky Palermo, one of the 36 artists I invited to Edinburgh as representatives of Düsseldorf as the city which had successfully challenged New York in the late '60s as the art world capital for contemporary artists.

The conurbation of Düsseldorf, Cologne and Bonn on the confluence of the Rhine and the Ruhr provided the heartland of the West German economic miracle and artists from all over the art world were attracted there. Among them was Blinky Palermo, who was born Peter Schwarz in Leipzig in 1943. Like a significant number of the *Strategy: Get Arts* artists, he personified the European diaspora which had caused many artists born in Communist East Europe to move westwards. He had benefited from the teaching of Joseph Beuys at the Düsseldorf Kunstakademie, and earned the respect of Beuys' professorial colleagues, Gunther Uecker and Gerhard Richter. He was present in the studio of Gerhard Richter when he and Gunther earned the respect of Beuys' professorial colleagues, Gunther Uecker and Gerhard Richter. He was present in the studio of Gerhard Richter when he and Gunther Uecker agreed with me that the responsibility for bringing the exhibition from dream to reality would depend on the willingness of the artists to travel to Edinburgh and make site-specific work.

Blinky Palermo responded with his work entitled *Blue, Yellow, White, Red*. It was a wall painting inspired by the main stairwell and entrance hall of Edinburgh College of Art. The College bore a distinct resemblance to the Düsseldorf Kunst Academie. So he felt 'at home', as I did because this was my Alma Mater in the early '50s. I chose it as the ideal setting for an exhibition which I wanted to provide an art education for Edinburgh Festival-goers to learn to take seriously the contemporary visual arts. Palermo's art work was positioned in relation to other site specific works by Klaus Rinke whose high pressure water sculpture offered a daunting

challenge to all those daring to enter through the main door of the College.

The stairway itself was littered with Stefan Wewerka's broken chair sculptural installation. The sound of a banging door could be heard, part of the three-week long sound sculpture by Gunther Uecker in collaboration with Friedhelm Döhl and which guided the gallery-goer to 'a sharp corridor of butchers knives blunted by order of the Edinburgh police'.

The recent Edinburgh College of Art exhibition focused on the fact that the Palermo wall painting had been painted over, and indeed all traces of the exhibition had been removed by the decision of the College authorities. The exhibition showed how Palermo's work had been reconstructed. This was in relation to a two-day international conference entitled Four Colours Suffice: Palermo, Art and Architecture. In relation to both this exhibition and conference, Edinburgh University's Talbot Rice Gallery presented an exhibition of Palermo's works on paper from the archive of the Kunstmuseum in Bonn.

At the same time, at The Scottish National Gallery of Modern Art, there was the exhibition *Strategy: Get Arts Revisited*, drawing from the National Gallery's Archive material and from that of the Demarco European Art Foundation as well as that of the photographer, George Oliver.

The Demarco Skateraw Project exhibition was housed in a large-scale barn specially constructed by Johnny Watson on his farm at Skateraw, near Dunbar on the East Lothian coastline in close proximity to the Torness Nuclear Power Station. As a farmer and seed merchant, Watson fully supports the Beuysian ideals which link

the worlds of the farmer and the environmentalist with that of the artist. His personal commitment to the exhibition's subtitle *Agri-Culture* has caused many of his fellow farmers to become involved.

The exhibition was opened to an appreciative public from August until October and is now open by appointment over the winter months, with a highlight planned for 9 February when there will be the private viewing of an art work by Ken McMullen as a result of his collaboration with John Berger and the nuclear physicists associated with the European Centre for Nuclear Research in Switzerland. This work will transform Torness Nuclear Power Station into a large scale sculpture, entitled *Loumin de Loumine*. It will make manifest the spirit of *Strategy: Get Arts*. It will bring back memories of how Joseph Beuys chose to celebrate the tenth anniversary exhibition of *Strategy: Get Arts* in 1980, taking into account the approach of the year 1984 made famous by George Orwell. Beuys designed an exhibition poster which showed him with a spade digging a ploughed field close to a nuclear power station. The wording on the poster took the form of a question 'What's to be done in 1984?' It was a reference to Lenin's exhortion to his fellow revolutionaries as well as to the world of Big Brother. It could well have been designed for Ken McMullen.

For the 20th anniversary exhibition at the 1990 Festival, I chose Gunther Uecker to make his exhibition 'Pictland Garden'. It was inspired by the stuff and substance of Scotland's geology and history. He acknowledged the fact that he had been attracted to Scotland, as indeed had Joseph Beuys, by the cultural heritage of the Celts and Picts.

The 25th anniversary exhibition of *Strategy: Get Arts* took the form of an 'Action' by Henning Christiansen and his wife, Ursula Reuter, at Edinburgh College of Art in the very life-room in which Henning Christiansen had collaborated with Joseph Beuys to create *Celtic (Kinloch Rannoch) The Scottish Symphony*. This was inspired by Beuys' interest in the European Celtic cultural heritage and the mythology evoked by the legendary exploits of King Fingal and his son, Ossian. Stories which linked Scottish and Irish cultural traditions. The 'Action' also took place on Rannoch Moor, beside the Beuys memorial set up in 1990 by George Wyllie.

It is a pity that the massive Dada exhibition at the Pompidou Centre which opened last October is destined for the United States and not for the UK. It provides vital information on the development of Dadaism, and therefore the cultural heritage shared by the *Strategy: Get Arts* artists and the artists represented in the Romanian, Polish, Austrian, French and Yugoslav exhibitions which I presented over a three-year period, 1971–74, and which included the exhibitions related to 'Edinburgh Arts', the Demarco Gallery's experimental summer school in the spirit of Black Mountain College. This school enabled me to invite Joseph Beuys to teach alongside Buckminster Fuller, as a leading figure in the history of Black Mountain College and to have Beuys teach alongside Tadeusz Kantor and the Polish artists of Kantor's Cricot Two Theatre, as well as with the Romanian *avant-gardist*, Paul Neagu.

Tadeusz Kantor contributed an art work for 'Edinburgh Arts 72' which defined the difference between the true and false *avant-garde*. He entitled it *A Demarcation*

Line. He insisted, 'It must be made everywhere and always, quickly and firmly as it will function anyway, whatever we choose to do automatically and relentlessly leaving us on one side or the other.'

Richard Demarco
January 2006

Tadeusz Kantor And Joseph Beuys

Tadeusz Kantor and Joseph Beuys were undoubtedly two outstanding artists in that 20th century period between the two great wars and ending as the decade of the 1980s had come to a close. They both survived against the odds the horror of the Second World War and a significant part of the 50 year period of the Cold War.

In many ways, they both personified their national identities. I cannot imagine the art of Kantor originating from any other culture than that of Poland, and, certainly, I cannot imagine the art of Joseph Beuys originating in any other culture other than that of Germany.

The landmass of both Germany and Poland could be defined as 'the heart of Central Europe'. Realising all this, I decided that they both had a great deal to contribute to my concept of 'Edinburgh Arts' as an experimental university of the arts inspired by the Edinburgh Festival. They are both outstanding examples of artists/teachers. Their impact on their fellow 'Edinburgh Arts' faculty members, and those who were privileged to be their students defined their exemplary teaching methods. I decided that the Demarco Gallery's 'Edinburgh Arts' project as an experimental university of the arts should focus on the best possible use of Tadeusz Kantor's and Joseph Beuys' capacity to teach and to make the process of their teaching ascend to the condition of enduring art within the context of late 20th century modernism.

I was privileged to collaborate with Joseph Beuys from 1970 until the year of his death in 1986 and with Tadeusz Kantor from 1969 through to the year of his

death in 1990. I regard myself as most fortunate in that they both shared my view that the true *avant-gardiste* should always reveal a healthy respect for the history of ideas beyond the limitations of the history of art.

In 1972, by committing myself to the experiment of 'Edinburgh Arts', I transformed the Demarco Gallery and therefore its *raison d'être* into an institution where the manifestations of all the arts could be utilised. I offered both Tadeusz Kantor and Joseph Beuys the most unlikely places to work as artists and as teachers, far from the safe environment of the Demarco Gallery. I offered them the challenge of a building which housed a well-established art school, namely Edinburgh College of Art, a palatial building possessed of large-scale and impressive studios. I also offered them the insalubrious and vulnerable interior of what had been at one time Edinburgh's equivalent of London's Bedlam, a combination of a mad-house, a hospital and a prison. The building had been derelict for over ten years. It belonged to the University of Edinburgh which had no plans for its development. It was rightfully known as the Forrest Hill Poorhouse. Its exterior walls abutted those of the historic Greyfriars Churchyard. It was within walking distance of Edinburgh College of Art. To further emphasise the importance of the radical steps to be taken to transform the main purpose of the Demarco Gallery into a place of study and learning, I was fortunate in 1973 to make use of the classrooms and gymnasium of the recently vacated building known as Melville College, one of Edinburgh's most prestigious private secondary schools for boys. 1973 was the year of its sad demise. Its main entrance was a few minutes walking distance from the doorway of the Demarco

Gallery, therefore, when I think of highlights in the careers of both Joseph Beuys and Tadeusz Kantor, I think of these highlights in the ways in which they utilised the wide range of learning spaces offered to them by a combination of Edinburgh College of Art, the Forrest Hill Poorhouse and Melville College. It seemed inevitable that the worlds of Joseph Beuys and Tadeusz Kantor should entwine in these spaces and, in particular, in The Forrest Hill Poorhouse where a Beuysian dimension was added to Tadeusz Kantor's Cricot 2 Theatre production of the play by Stanislaw Ignacy Witkiewicz entitled *Lovelies and Dowdies*.

They both made good use of Melville College to give master classes, one of which was an 'Action' by Joseph Beuys, famously known as the *Twelve Hour Lecture*, inspired by the life of Anacharsis Cloots embroiled in the terror of the French Revolution. Tadeusz Kantor gave masterclasses in an adjoining classroom. They both put to good use the sculpture court of Edinburgh College of Art and the main life room studios.

They also paid due respect to the space offered of a journey in the form of a voyage circumnavigating the coastlines of the British Isles on board a sailing ship as a replica of Charles Darwin's 'HMS *Beagle*'. This symbolised my concept of the 'Demarco Gallery under full sail' towards what Joseph Beuys defined as 'The Offing', well beyond the horizon on any seascape. They were both encouraged to consider the physical reality of Scotland in the 1970s. Thus my memories of Joseph Beuys include his expeditions into the Celtic world across the Moor of Rannoch towards the harbour of Oban where he found himself in the Hebridean world of St Columba and the legendary figure of Ossian, the

son of Fingal. I can also see him clearly in the Scottish Borders' world of Sir Walter Scott, in the castle and domain of Bemersyde, the home and studio of the painter Dawyck Haig. Tadeusz Kantor and his Cricot 2 Company found themselves 'at home' in another part of the Scotland's Borders in the Peeblesshire home of Matilda O'Brien.

I think I have every right to say that I never 'presented' their work simply as artists. It is nearer the truth to say that I 'collaborated' with them as fellow artist/ teachers. Now, in this year celebrating the 100th anniversary of the birth of Tadeusz Kantor, I must place them at the very heart of what the Demarco Archive and Art Collection makes manifest. The word 'archive' could be seriously inaccurate. The German word *Gesamtkunstwerk* could be more appropriate. This means a 'total art work'. This is a word which could be applied to the totality of the art made by both Tadeusz Kantor and Joseph Beuys under the aegis of 'Edinburgh Arts'. They were both totally committed to this experiment in art education which resulted from the collaboration between the Demarco Gallery and Edinburgh University's Schools of Scottish Studies and Extra-Mural Studies. Thus they were both part of a programme which associated them with fellow members of the 'Edinburgh Arts' faculty such as Roland Penrose, Buckminster Fuller, Paul Neagu, Marina Abramović, Ian Hamilton Finlay, Magdalena Abakanowicz, David Baxandall, Douglas Hall, Colin Thomson, Hugh MacDiarmid, Hamish Henderson, Sorley MacLean, George Mackay Brown, Peter Selz, John Calder, Mark Francis, Cordelia Oliver, Caroline Tisdall and Sandy Nairne.

I shall never forget the moment when I introduced Tadeusz Kantor to Joseph Beuys in the living room of my Edinburgh house. That meeting has meant that their names are inseparable in my mind as defenders of what Tadeusz Kantor defined as the 'true *avant-garde*', rooted in his firm belief that a 'Demarcation Line' exists, separating the two opposing worlds inhabited by the true and the false *avant-gardiste*. As the years roll by at ever-increasing speed, I hesitate to define them simply as 20th century artists. If there is a future for art in the 21st century, they are both surely still leading the vanguard and they are firmly placed on the side of Kantor's 'Demarcation Line' where truth and beauty can be found expressed in the poetry of John Keats, who simply defined art in the words – 'Beauty is truth, truth beauty'.

It should be noted that, in the Official Edinburgh International Festival exhibition catalogue which listed all the Polish artists represented, Tadeusz Kantor chose to represent his art as his 'Demarcation Line'.

I regard it as the best possible description of the world in which the names of Joseph Beuys and Tadeusz Kantor are inseparable when I think of the long history of the Edinburgh Festival which, next year, will celebrate its 70th anniversary. This exhibition in the 100th anniversary year of the birth of Tadeusz Kantor will surely remind us that the Edinburgh Festival came into being because its founders believed that the language of art is essentially the language of healing, so much needed in the war-torn world of Europe in 1947. There is ample evidence that our 21st century in its second decade is still in need of art as the language of healing.

Joseph Beuys demonstrated his profound respect for Tadeusz Kantor, and the Polish art world that he personified, when, during the period of martial law in Poland, he decided to drive with his wife, Eva, and his children, Jessyka and Wenzel, from Düsseldorf to Łódź to provide Ryszard Stanisławski, Director of the Muzeum Sztuki, Łódź with a gift of over 600 of his art works. This unique collection is now known as *Polen Transport*. The Beuys family then drove on to Poland's Masurian Lakes to demonstrate their preparedness to holiday in Poland, even when it was enduring the indignity of Martial law. Joseph Beuys knew that the process of healing and reconciliation and friendship had to be made clear when the Polish Solidarity movement was being tested to the breaking point. His friendship with Tadeusz Kantor personified the inevitability of the cultural dialogue now enjoyed between Poland and Germany.

Maria Anna Potocka
Director, Museum of Contemporary Art in Kraków, 2015

Joseph Beuys as Artist-Teacher

I regarded Joseph Beuys as the personification of the artist-teacher in relation to his professorship at the Kunstakademie Düsseldorf and as a Faculty Member of 'Edinburgh Arts' (the Demarco Gallery's Experimental University of the Arts 1970–81).

When I asked Joseph Beuys to define the nature of his art, his reply was short and simple. He said, 'My art is my teaching'. His art was therefore an expression of his teaching methods.

When I think of the art which resulted from our collaborations in Scotland I associate his art most clearly with the physical reality of the blackboard, that classic symbol of the teacher's classroom as the place where the teacher deals with the important and onerous task that is teaching.

My four years studying fine art and design at Edinburgh College of Art from 1949 to 1953 and my one year of study at Edinburgh University's Moray House Teacher Training College from 1953 to 1954, and the two years of National Service undertaken thereafter as a sergeant in the Royal Army Educational Corps from 1954 to 1956, qualified me to teach at primary and secondary levels at Duns Scotus Academy for the education of Roman Catholic schoolboys from 1957 to 1967.

I was appointed art master to teach alongside Arthur Oldham as music master. He was, like Beuys, the very personification of the artist as teacher. He believed as I did that every Scotus Academy boy should be encouraged to find ways in which to express his birthright as a youthful human being possessed of creative energy.

Arthur Oldham was destined to become the founder-director of the Edinburgh International Festival Chorus. This led to his appointment as chorus master of the London Philharmonic and later the chorus master of the Paris Conservatoire.

In 1968, in my capacity as co-founder and deputy chairman of the Traverse Theatre Club and Art Gallery, I extended the space of my Scotus Academy classroom to both the stage and art gallery of the Traverse.

Then, in 1972, it seemed inevitable that the Richard Demarco Gallery should be transformed into an experimental art school in the Bauhausian spirit of Black Mountain College. This was a direct result of the new historically important exhibition presented as part of the official 1970 Edinburgh Festival exhibition programme with the palindromic title, *Strategy: Get Arts*.

This exhibition involved the close collaboration of the Kunsthalle in Düsseldorf with the Richard Demarco Gallery. It was made possible as part of the programme I devised from 1967–92 as director of the Edinburgh International Festival's exhibition programmes, which were devoted to the contemporary art of the European countries on both sides of the Iron Curtain during the Cold War in Europe.

Germany was divided by the Yalta Conference into East Germany and West Germany. Unlike East Germany, West Germany possessed a conurbation of three cities: Bonn as the capital of West Germany, Frankfurt and Düsseldorf, all associated with West Germany's industrial heartland and the confluence of the Rivers Rhine and Ruhr.

In the late '60s this conurbation had attracted a significant number of the international art world's most

noteworthy artists then being supported by a number of civic museums in the region of Nordrhein-Westfalen. For this reason I chose Düsseldorf as worthy of an Edinburgh Festival exhibition rather than New York, which for many art pundits would have been the obvious nodal point on the map of the international world of modern art in the year 1970.

Under the aegis of the *Strategy: Get Arts* exhibition, Joseph Beuys was introduced into the English-speaking art world of Western Europe, represented by Scotland during the period of the 1970 Edinburgh International Festival.

The Düsseldorf artists were not all German. They represented *avant-garde* movements in France, Romania, England, Switzerland, Ireland and even in New York.

I placed the *Strategy: Get Arts* exhibition in the Edinburgh College of Art. As an institution dedicated to the teaching of art and design this emphasised the fact that it was for me it was not just an exhibition but also a large-scale masterclass with a focus on the history of modern movements in art which had not been experienced in Scotland.

It provided me with an opportunity to engage Joseph Beuys as an artist-teacher in dialogue with those artists living and working in the British art world who deserved to be in fruitful dialogue with the artistic activities as yet unknown in London and Edinburgh.

I was pleased to see dialogues develop between Joseph Beuys and Scottish artists such as Dawyck Haig, Michael Docherty, Alan and Merilyn Smith, Rose Frain, Bill Scott, Dawson and Liz Murray, Hamish Pringle, Glen Onwin, Eileen Lawrence, and in particular George Wyllie and Alistair Park who took the trouble to extend

and strengthen these dialogues with Beuys by visiting him in his studio in Düsseldorf.

I was also pleased that Jon Schueler, the American painter, who had decided to forsake a burgeoning career in the New York art world for the Celtic world of Scotland, took the trouble to visit Joseph Beuys in Düsseldorf. He and Beuys had much in common. Both had survived the Second World War in the dominating factor of aerial warfare, in which Beuys wore the uniform of a Luftwaffe navigator flying for the much feared German Sztuka Bombers. Schueler wore the uniform of an American Bomber Command navigator. Both survived with terrible and long-lasting injuries, physical and mental. Their art was forged out of their traumatic war experiences. They became friends, deeply respectful of each other's art. Like Beuys, Schueler was an inspiring teacher in American art schools such as Yale University and the Maryland Institute College of Art.

Jon Schueler's profound understanding of Beuys' art caused him to perceive the true nature of the Beuys masterwork *Celtic (Kinloch Rannoch) The Scottish Symphony*. He experienced it as an example of 'performance art'. However, Jon Schueler also perceived it as a requiem for all the artists who preceded Joseph Beuys. Most of these artists he associated with his own life and art. Kenneth Dingwall, the Scottish artist and a good friend of Jon Schueler, agreed with him that this particular art work had indeed the characteristics of a requiem.

Johannes Stuettgen, one of Beuys' students who had accompanied Joseph Beuys on his journey from the Düsseldorf Kunstakademie to the 1970 Edinburgh Festival, had defined this particular Beuys art work as indeed a requiem. He displayed three pieces of paper

attached to a wall in the life room in which *Celtic (Kinloch Rannoch) The Scottish Symphony* was performed. The first piece of paper had a five-word question: 'Where are the souls of...?' The next piece of paper had a list of artists' names such as Casper David Friedrich, Albrecht Dürer, Vincent van Gogh, Kasimir Malevich, Paul Klee, William Nicholson (the father of Ben Nicholson).

Fr Freidhelm Mennekes (SJ) also identified many aspects of Beuys' art with the religious nature of the requiem. He is a Jesuit priest who became a friend of Joseph Beuys. He is an acknowledged expert on the 1969 Beuys masterwork entitled *Manresa*. This was inspired by the life of St Ignatius Loyola, the founder of The Jesuit Order. Like Beuys, Fr Mennekes suffered severe physical injury from human conflict. The process of his recovery could be likened to that of Beuys in that it contained a religious significance.

Freidhelm Mennekes wrote an enlightening book focused on Christian elements in Beuys' art, *Thinking Christ*. In 1989, I invited Fr Mennekes to take part in a one-day symposium at the Demarco Gallery in St Mary's School to focus on the significance of *Manresa*. The symposium brought together Jimmy Boyle and Alistair MacLennan as Scottish artists, and Professor John Haldane, the Scottish artist, theologian and moral philosopher. Together they considered the interface between Beuysian concepts of art and the history of Europe as Christendom. They also considered the fact that that part of the healing process which Beuys is identified with was the three-year period in which he chose to work as a farmer on the land of his friends the Van der Grinten brothers.

The life of a farmer is closely identified with every

aspect of the natural world. I was well aware that when I invited Joseph Beuys to Scotland I would have to introduce him to the world of the farmer and to the fact that at the heart of 'Edinburgh Arts' (as an experimental university of all the arts linking arts with all aspects of science) was the road from the urban environment of the Demarco Gallery in Edinburgh to that of 'The Road to Meikle Seggie' in the hillscape of Kinross-shire.

'Edinburgh Arts' was the Demarco Gallery's Scottish version of Black Mountain College in North Carolina, located on a farmscape. 'Edinburgh Arts' was firmly located on the farmscape associated with a farm named Meikle Seggie on the lower slopes of the Ochill Hills halfway between the Ledlanet farming estates and the market town of Milnathort. Ledlanet House and Estates were inherited by John Calder. As a world renowned publisher of such literary luminaries as Samuel Beckett and the French New Wave writers, and as a patron of opera, he established Ledlanet House as the Scottish equivalent of Glyndebourne Opera in Sussex.

Ledlanet opera season was presented along with an exhibition programme. This most certainly provided inspiration to myself and my friends who envisioned a space for all the arts in Edinburgh linked to Jim Haynes' Paperback Bookshop. This was essentially a meeting place for artists and a theatre and art gallery on a very small scale. It was closely identified with the publishing world of John Calder. This space was by then identified with a building on Edinburgh's Royal Mile close to Edinburgh Castle.

It was in this building that the Traverse Theatre came into being, which eventually led to the opening of

the Demarco Gallery, which led to the world of 'Edinburgh Arts'.

The development of 'Edinburgh Arts' in 1972 signalled the transformation of the Demarco Gallery into a place of education. The space of 'Edinburgh Arts' was an extension of the art studios of both Edinburgh College of Art and the Kunstakademie of Düsseldorf. It provided the space in which I could collaborate with Joseph Beuys as a fellow-teacher, using the language of all the arts as a healing balm helping to heal the wounds inflicted on Europe by the Second World War.

Richard Demarco, 2016

Artistic Detours: Joseph Beuys as an Anthropologist

On 27 April 2007 I was invited to give a keynote lecture on my collaborations with Joseph Beuys. It was part of a one-day symposium entitled *Artistic Detours: Joseph Beuys as an Anthropologist* held by the Symposium at the Academy for Irish Cultural Heritages (AICH), on the Magee Campus, University of Ulster, Derry/Londonderry.

I was inspired by the short essay by Dr Victoria Walters which summed up the importance of the symposium. I feel it is necessary to reproduce it in its entirety:

> In *The Taste of Ethnographic Things*, Paul Stoller writes of Joseph Beuys and Richard Rorty, 'Both these men travelled the secondary roads of inner space and have concluded that scholars and artists can no longer nestle within the comfortable confines of their Truth-seeking disciplinary institutions; rather scholars must extend themselves to others in order to initiate and maintain a dialogue – to keep the conversation going, to heal imbalances between the 'savage' and the 'civilized', the natural and the mechanistic. Discussion of these philosophic and artistic detours sets the stage for an excursion into the pragmatist notion of radical empiricism – a detour leading, perhaps, to a more sensual, open ethnography.'
>
> Stoller, 1989, p.145

This one-day symposium will seek to revisit aspects of Beuys' practice, with a particular, but not exclusive focus on his visits to Ireland and Scotland in the 1970s, in order to assess the effect that Beuys' extension of art

into anthropology has had on the disciplines of anthropology, ethnology and art and his continuing legacy for these fields. Underpinning this focus is a concern with the importance and value of dialogue between artists and anthropologists or ethnographers. Questions for exploration include: What avenues has Beuys' practice opened up for anthropological and/or artistic praxis? What have the effects of Beuys' legacy been on art, ethnography and cross-disciplinary practice in these areas? How did and does his work serve as an inspiration to artists and ethnographers to maintain productive and self-reflexive conversations, as encouraged by Arnd Schneider and Christopher Wright in their recent publication *Art and Anthropology*? Does a discussion of Beuys' work constitute 'a detour leading, perhaps, to a more sensual, open ethnography' which is still a relevant agenda in the context of contemporary ethnographic and artistic debates and practice?

I regard the questions posed in this essay as most important and relevant to anyone seeking to define the nature of the art and career of Joseph Beuys. I once asked him to define his art himself. His reply was short and to the point, 'My art is my teaching.' This helps explain why he used the blackboard, an obvious symbol of his work as artist-teacher. His 'Actions' with blackboards were for me symbolic of a form of master class.

Certainly *Celtic (Kinloch Rannoch) The Scottish Symphony* could easily be regarded as such. So too could his 'action' entitled *Three Pots Action* in the Demarco Gallery's Forrest Hill Poorhouse gallery, and his *Twelve Hour Lecture* inspired by the life of Anacharsis Cloots and his role in the French Revolution. This was performed in the gymnasium of Melville College when

it was used by the Demarco Gallery's 'Edinburgh Arts' experimental summer school. Beuys used four blackboards, each from a different Melville College classroom. He suspended them from the walls of the College gymnasium and proceeded to draw upon each blackboard to provide a visual dimension to the words he spoke in his *Twelve Hour Lecture* as a performance art work.

The *Jimmy Boyle* diptych consisting of two blackboards dedicated to Jimmy Boyle as an artist; Jimmy was serving life at Barlinnie Prison. Beuys believed that everyone must be regarded as an artist – particularly anyone in prison – because an artist's life is nothing but an expression of freedom.

At the conclusion of the one-day Artistic Detours symposium I was invited by Dr Victoria Walters to plant an oak tree along with a basaltic stone on the University of Ulster's campus in Derry. This was in homage to Joseph Beuys' last gigantic work, *7,000 Oaks*. Fittingly, 'Derry' means 'place of oak trees' in old Gaelic. The one oak tree will act as a reminder that it should be accompanied by another 6,999 so that a forest of oak trees can flourish in Derry, the city of St Columba. It was he who persuaded the Druidic priests that it was not enough simply to worship the oak tree but more important to worship the Creator responsible for the universe, which contains the oak tree and in which the artist and the environmentalist live and work in harmony with nature.

Richard Demarco, 2016

▶ **1970 May**

Within an hour of landing at Edinburgh Airport Joseph Beuys saw this white horse standing in a field at Turnhouse Farm – reminding him of his 'Action' with a white horse which he referred to as 'Ephigenie' in his 1969 performance in Frankfurt entitled *Titus/Ephigenie*. This involved Joseph Beuys on stage in dialogue with a white horse.

Joseph Beuys viewing the reality of the Forth Rail Bridge from South Queensferry Harbour – accompanied by Georg Jappe, Jim Haritans and Jennifer Gough-Cooper.

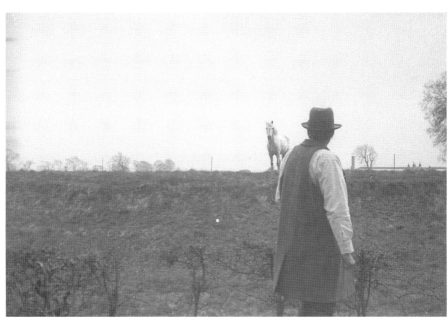

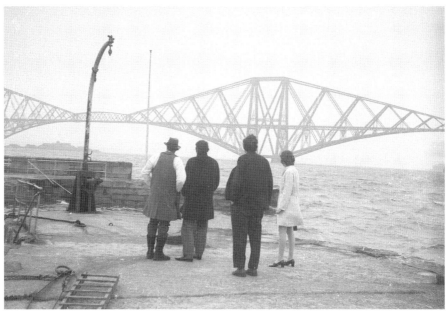

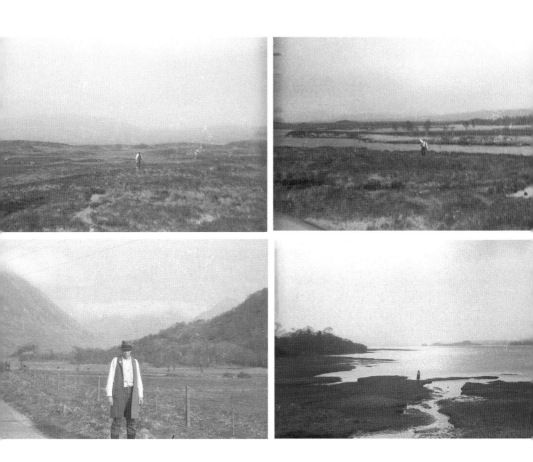

1970 May

Joseph Beuys, in preparation for his 'Action' *Celtic Kinloch Rannoch: The Scottish Symphony*, exploring the Moor of Rannoch, the shoreline of Loch Awe, and Glencoe.

▶ **1970 May**

Joseph Beuys exploring the 'Land of Macbeth' at Castle Stalker by Loch Linnhe and Kilchurn Castle on Loch Awe.

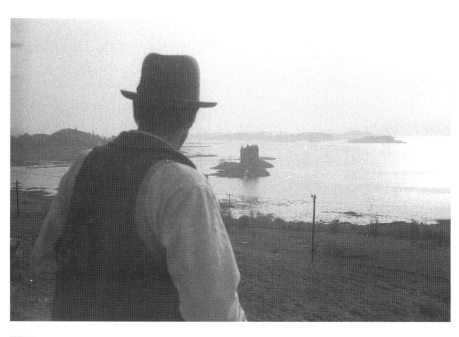

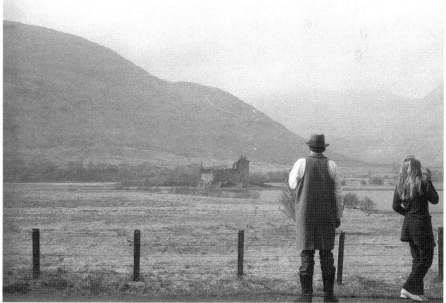

May 1970 – London

Joseph Beuys in a Bloomsbury café with the American art critic
Seth Seigelaub, Georg Jappe and Peter Townsend, Editor of *Studio
International*.

May 1970 – London

Joseph Beuys in London meeting with Georg Jappe at the home of
Richard Hamilton and Rita Donagh.

1970

Joseph Beuys his wife Eva, son Wenzel and daughter Jessyka with Jürgen Harten at Edinburgh College of Art. Hamish Pringle is installing the exhibition *Strategy: Get Arts*.

August 1970

Joseph Beuys with his family viewing Edinburgh from the roof of Craigmillar Castle.

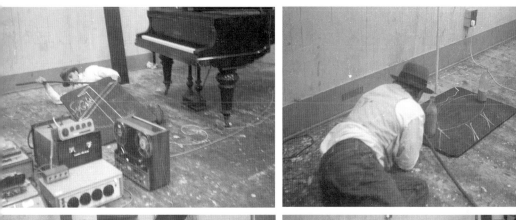

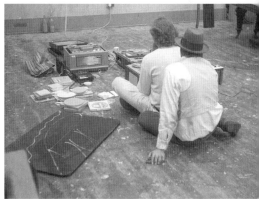

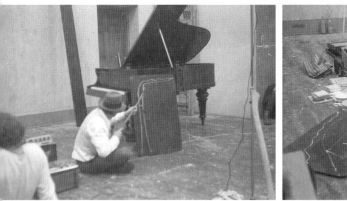

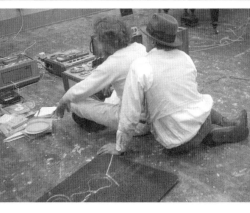

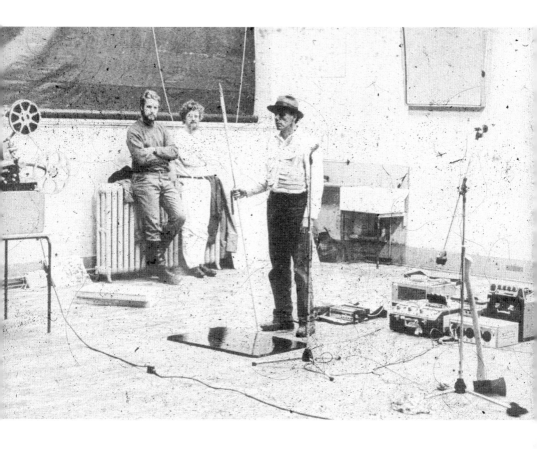

◁ 1970

Six images of Joseph Beuys and Henning Christiansen 'in performance'
creating *Celtic* (*Kinloch Rannoch*) *The Scottish Symphony* at Edinburgh
College of Art.

▲ **August 1970**

Joseph Beuys standing 'on guard' for one hour over a blackboard
symbolising the 'Tomb of the Unknown Soldier' at Edinburgh College
of Art.

▲ **August 1970**

Klaus Rinke, Monika Baumgarten and Linden Travers at Edinburgh College of Art during the exhibition *Strategy: Get Arts*.

▶ Joseph Beuys and Henning Christiansen performing *Celtic* (*Kinloch Rannoch*) *The Scottish Symphony*.

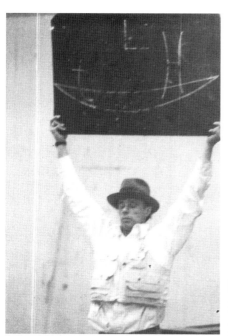
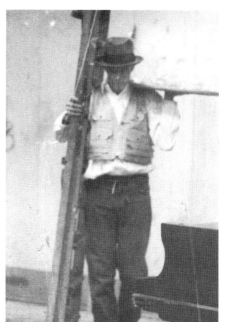
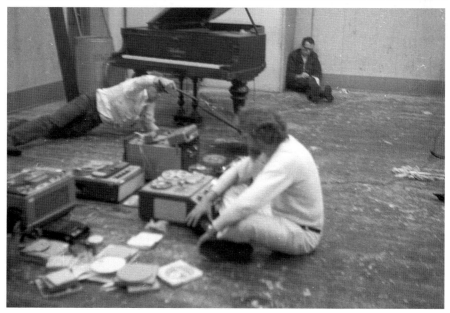

▲ **August 1970**

Joseph Beuys contemplating the three pieces of paper installed by Johannes Stüttgen. On one are the words 'Where are the souls of...' The second contains a list of all the artists who inspired him – 'A list of Artists' and finally on the third piece of paper are the words 'and Leonardo da Vinci'.

▶ *above*: Julian Glover and Timothy West as 'Boswell and Johnson' with Sally Holman in the Edinburgh College of Art life studio containing an exhibition of Beuys' *Arena*: a documentation of all the art works he made leading to *Celtic (Kinloch Rannoch) The Scottish Symphony*.

below: Lesley Benyon plays with Joseph Beuys' children while Eva Beuys looks at the *Arena* installation at Edinburgh College of Art.

1973
Joseph Beuys in collaboration with Tadeusz Kantor in the Cricot Two
Theatre performance of Witkiewicz's play *Lovelies and Dowdies* at the
Forrest Hill Poorhouse.

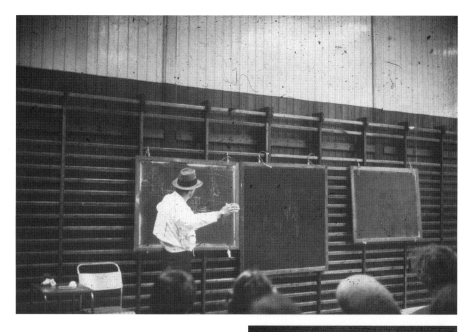

1973

Joseph Beuys in his performance entitled *The Twelve Hour Lecture* in Melville College gymnasium.

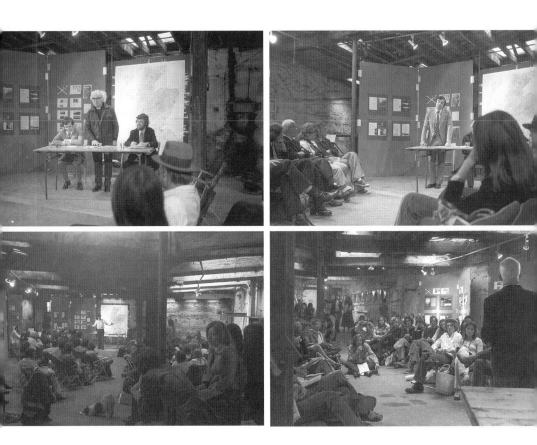

1974

top left: Father Anthony Ross, the Rector of Edinburgh University (1979–1982).

top right: Gavin Strang MP with Caroline Tisdall and Joseph Beuys.

At the Forrest Hill Poorhouse, *The Black and White Oil Conference* questioning the long-term future of North Sea oil.

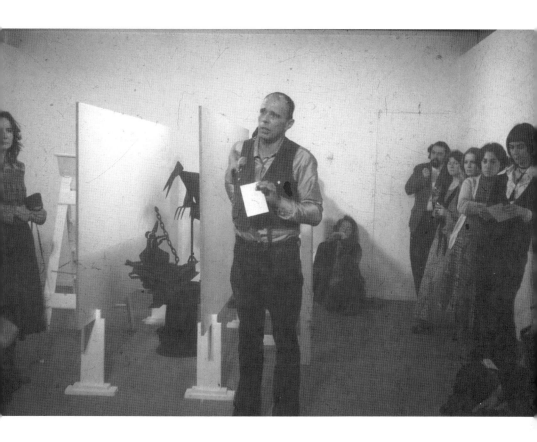

1976

Joseph Beuys at the Demarco Gallery in Monteith House 'in performance' related to the Jimmy Boyle sculpture entitled *In Defence of the Innocent*.

1976

Joseph Beuys in his studio in Oberkassel signing the print *Beuys, Lady Rosebery and Buckminster Fuller* in the Royal Botanic Gallery, Edinburgh.

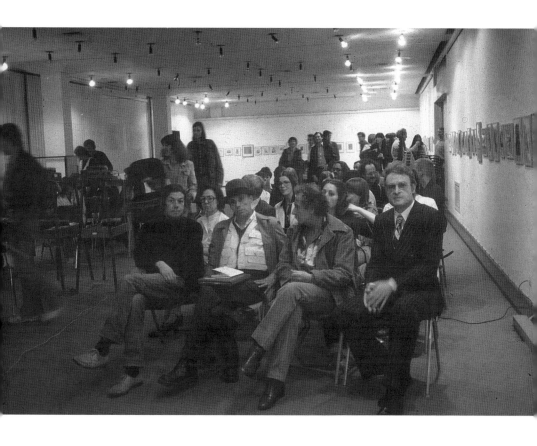

1978

Joseph Beuys accompanied by Jürgen Harten and Georg
Jappe attending Richard Demarco's lecture on 'Edinburgh
Arts' at the Kunsthalle in Düsseldorf.

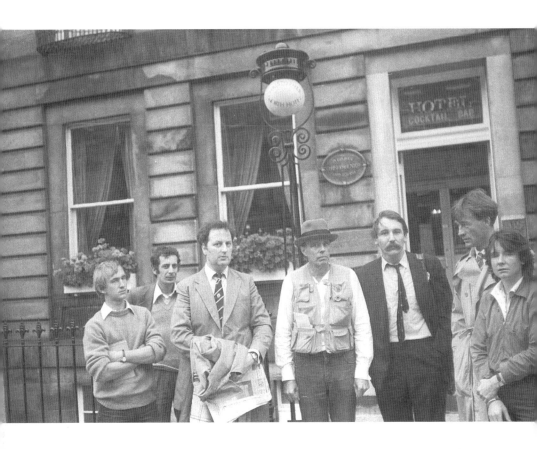

▲ 1980

Joseph Beuys outside The Christopher North Hotel with the legal team he had gathered to take a court action against the Secretary of State for Scotland, in support of Jimmy Boyle benefitting from The Special Unit in which, as a prisoner in HM Prison Barlinnie, he could develop his career as an artist.

▶ Joseph Beuys at the Demarco Gallery in Gladstone's Court making *The Jimmy Boyle Blackboards*.

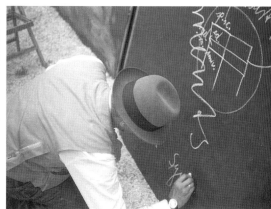

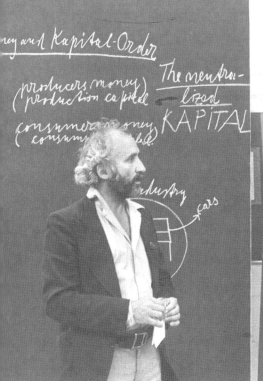

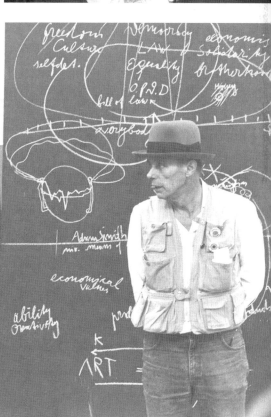

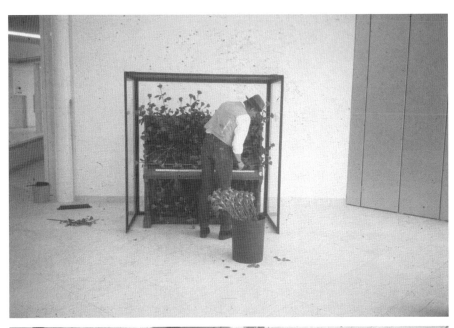

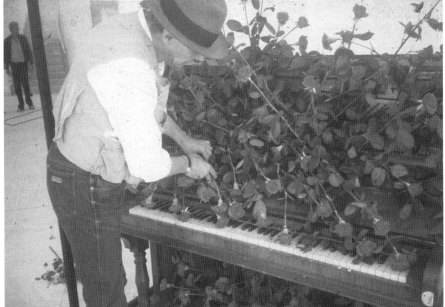

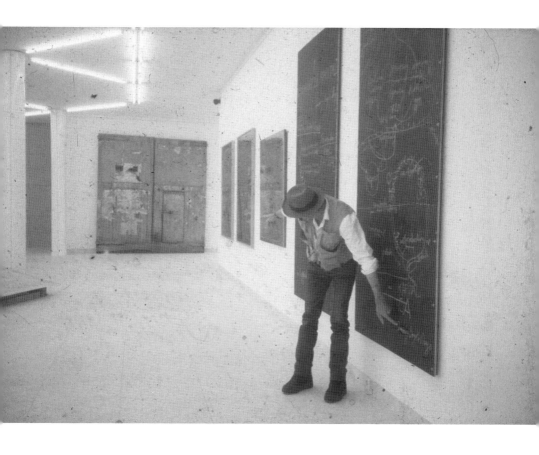

1980

Joseph Beuys at the opening of the Mönchengladbach Museum with *The Jimmy Boyle Blackboards* exhibited near to *The Poorhouse Doors*.

◀ **1980**

Joseph Beuys installing his piano with red roses and red carnations.

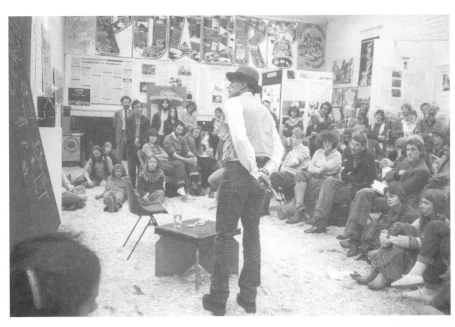

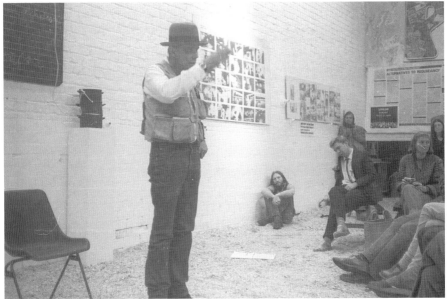

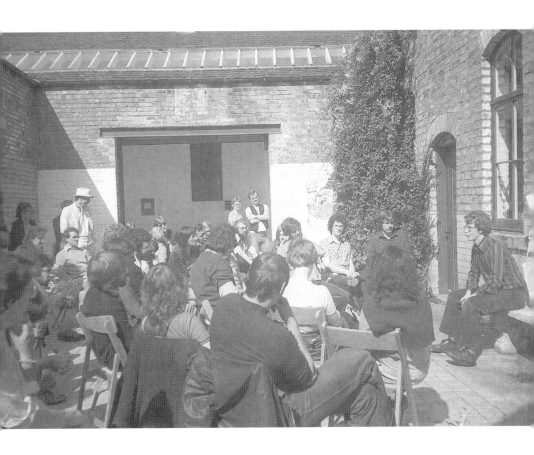

1980

Beuys' audience fill the courtyard of the Demarco Gallery during the 1980 session of 'Edinburgh Arts'.

◁ **1980**

Joseph Beuys involved in making *The Jimmy Boyle Blackboards* and, at the same time, lecturing to his students about his concept of 'Social Sculpture'.

1980

Count Panza di Biumo in conversation with Douglas Hall at The Scottish National Gallery of Modern Art in Inverleith House.

1980

Jessyka and Wenzel Beuys with their father, Joseph Beuys, in conversation with George Wyllie at The Scottish National Gallery of Modern Art.

1980

Michael Spens, Johannes Cladders and Giuseppe Panza di Biumo at the private view of the Mönchengladbach exhibition in Inverleith House.

1981

Joseph Beuys with his family, and Scottish artists George Wyllie and Dawson Murray, at the entrance to the Scottish National Gallery of Modern Art in The Royal Botanic Garden of Edinburgh.

1981

Joseph Beuys and Count Giuseppe Panza di Biumo at the entrance to The Gallery of Modern Art in Inverleith House.

1981

Duncan Macmillan, Michael Spens and Johannes Cladders with Count Giuseppe Panza di Biumo at the private view of the 1980 Edinburgh Festival exhibition in Inverleith House.

1981

Joseph Beuys introducing his family to Jimmy Boyle in The Royal Botanic Garden of Edinburgh.

▶ 1981

Joseph Beuys viewing the dome built by Robert Adam in the 18th century 'Old Quad' of Edinburgh University.

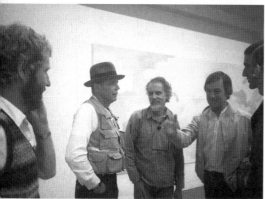

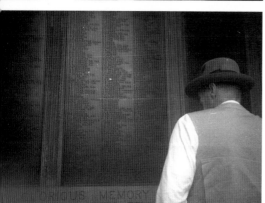

Top

1981

Joseph Beuys at the University of Edinburgh studying a room full of Henry Raeburn portraits of Scottish Enlightenment luminaries.

Middle

1981

In the Edinburgh University Talbot Rice Gallery, Joseph Beuys visits the Jon Schueler exhibition. Jon Schueler took the bold step of setting aside a part of the exhibition space as a studio to enable him to paint new paintings of the skies viewed from Mallaig towards the Sound of Sleat and the Isle of Skye.

Below

1981

Joseph Beuys studying the War Memorial of Edinburgh University students who had lost their lives in the First World War.

1981

Left to right, Wenzel Beuys, Joseph Beuys, Lord Haig and Jessyka Beuys being led into the main door of Bemersyde Castle.

Overleaf

Top left

1981

Joseph Beuys and Lord Haig in conversation in the drawing room of Bemersyde Castle. Both had survived the experience of World War Two; their wartime experiences had inspired them to become artists.

Below left

1981

Joseph Beuys in the Scottish Borders' world of Dawyck Haig at Bemersyde Castle, close to the ruins of Dryburgh Abbey where Sir Walter Scott is buried alongside Field Marshal Douglas Haig.

1981
Dawyck Haig, Anthony d'Offay and Johannes Cladders in conversation with Joseph Beuys on the battlements of Bemersyde Castle.

1986
Two oak trees, the first planted by Joseph Beuys at the *Documenta VII* in 1982, the second planted by his son, Wenzel, at the *Documenta VIII* in 1987. This shows how these trees were planted beside basaltic stones. They are planted in front of The Fridercianum, the main exhibition building of the *Documenta*.

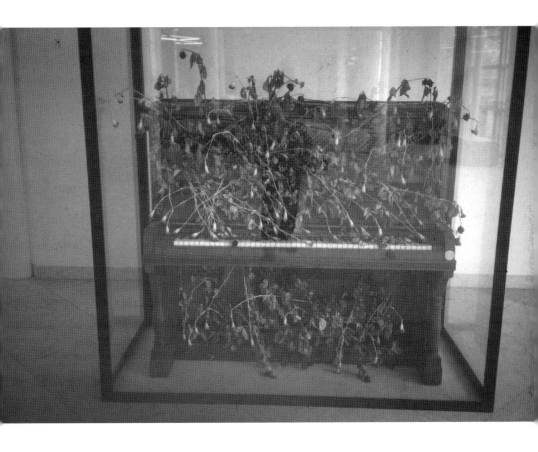

1987

On a Demarco Gallery 'Edinburgh Arts' expedition to Mönchengladbach, the most memorable image in the collection of the museum was the piano sculpture. The red roses and carnations were now no longer red and freshly alive; they were brown and withered indicating the passing of time.

The Beuys legacy

Joseph Beuys has left a distinct and unique legacy as an artist who questioned deeply the nature of the 20th century art world, not just expressed in the visual arts but in the multi-faceted nature of all the arts. For him, the quintessential nature of his own art existed in his self-appointed role as a teacher. For him, every aspect of the arts and the sciences were interwoven.

He used the widest imaginable range of materials, not restricting himself to the acceptable use of pencil, pen or brush on two-dimensional surfaces or indeed the chisel or hammer in the fashioning of sculpture. He used his physical presence as an instrument in the making of his art and that included the sound of his voice, not just in human speech but in all manner of sounds. His art was not made for the art market or restricted to the world of human beings. It was placed firmly in the animal kingdom, in the studio and class-room and in the most unlikely places and institutions such as the maximum security prison of Barlinnie in Glasgow and the caged environment where he engaged himself in fruitful dialogue with a coyote.

Beuys expanded the world of art and the work of the artist to embrace, and alter for the better, the very structure of society. He said, most controversially that 'everyone is an artist'. By that he stressed the truth that everyone is born to be creative and that 'Kunst ist Kapital'. For him, translated, that does not mean art equals money but the true value of every human being's potential to live a creative life.

He personified the unique cultural heritage of Europe and, despite the fact that he survived the Second

World War wearing the uniforms of a *Luftwaffe* and *Wehrmacht* combatant and that his post-war life, until his death in 1986, was spent in a Germany divided by The Iron Curtain. He worked with astounding energy on mental, physical and spiritual levels. His art questioned the nature and purpose of the human being in society. His concept of 'social sculpture' involved him in the self-imposed superhuman task of restructuring the stuff and substance of society.

He certainly added a new and much-needed dimension to the meaning of the Edinburgh International Festival. His numermous contributions reminded festivalgoers of the original concept of the festival as an invaluable means of using the arts as a healing balm, as an antidote to human conflict. His art forever questions deeply the ways in which the contemporary art world has been subsumed by an ever-burgeoning materialistic world.

His art aspired to the condition of prayer. For that reason, his great masterwork, *Celtic (Kinloch Rannoch) The Scottish Symphony* should be regarded as a Requiem, honouring all the great artists who surrounded him through his life when he recovered from what is now known as post-traumatic stress disorder.

My most enduring memory of him is as a figure, like a sentinel, standing motionless over a blackboard as a symbol of what he termed The Grave of the Unknown Artist. This year, with the weight of all my memories of the Edinburgh Festival since 1947, that image of Beuys above all gives me hope for the future of the 21st century. Like all the great artists he respected such as William Shakespeare, James Joyce and Leonardo da Vinci, Beuys knew that art is the one language which

enables us to defend the interweaving of truth and beauty.

Richard Demarco
July 2016

Luath Press Limited
committed to publishing well written books worth reading

LUATH PRESS takes its name from Robert Burns, whose little collie Luath (*Gael.,* swift or nimble) tripped up Jean Armour at a wedding and gave him the chance to speak to the woman who was to be his wife and the abiding love of his life. Burns called one of 'The Twa Dogs' Luath after Cuchullin's hunting dog in Ossian's *Fingal.* Luath Press was established in 1981 in the heart of Burns country, and now resides a few steps up the road from Burns' first lodgings on Edinburgh's Royal Mile.

Luath offers you distinctive writing with a hint of unexpected pleasures.

Most bookshops in the UK, the US, Canada, Australia, New Zealand and parts of Europe either carry our books in stock or can order them for you. To order direct from us, please send a £sterling cheque, postal order, international money order or your credit card details (number, address of cardholder and expiry date) to us at the address below. Please add post and packing as follows: UK – £1.00 per delivery address; overseas surface mail – £2.50 per delivery address; overseas airmail – £3.50 for the first book to each delivery address, plus £1.00 for each additional book by airmail to the same address. If your order is a gift, we will happily enclose your card or message at no extra charge.

Luath Press Limited
543/2 Castlehill
The Royal Mile
Edinburgh EH1 2ND
Scotland
Telephone: 0131 225 4326 (24 hours)
email: sales@luath.co.uk
Website: www.luath.co.uk